SIR JOHN EVERETT
MILLAIS

Russell Ash

PAVILION

SIR JOHN EVERETT MILLAIS
1829–96

John Everett Millais was born in Southampton on 8 June 1829, the youngest son of John William and Emily Mary Millais. His father was a prominent inhabitant of Jersey and a long-serving officer in the island's militia. Emily Mary, *née* Evamy, whose family operated a successful saddlery business in Southampton, was a young widow who had been previously married to Enoch Hodgkinson, by whom she had two sons. Her marriage to John William produced two other children, John's sister Emily, who married John Johnson-Wallack, an American, and emigrated to the United States, and John Everett's elder brother William, who remained his close companion throughout his life.

There had long been Millais residents of Jersey (several landmarks on the island bear the family name), tradition relating that their ancestors had settled there at the time of William the Conqueror. John's early years were spent on the island near St Helier, apart from a spell in Dinan, Brittany, from 1835 to 1837. Following his expulsion from school (after just three days, for biting his teacher's hand), and suffering from poor health, it was decided that he should be educated at home, where he came under the influence of his mother, a powerful personality. At the age of four he began to draw and when he began taking art lessons with a Mr Bessell his prodigious talent became apparent. It was said that by the age of seven, he could stroll on the beach, return home, and draw an astonishingly accurate picture of the scene; he also did portrait drawings of local soldiers. He was encouraged to pursue an artistic career by a number of local dignitaries, who included Sir Hilgrove Turner, former Lieutenant Governor of Jersey (whose signature appears as a tribute on the document held in Millais's later painting, *The Order of Release*).

To foster their son's burgeoning skill, the Millais family travelled to London in 1838, setting up home in a rented house in Charlotte Street, to the north-west of the British Museum. Carrying a letter of introduction, they took John to Sir Martin Archer Shee, President of the Royal Academy since 1830. He was so disbelieving that someone so young could have produced the drawings he was shown that he asked John to draw a sculpture there and then, and was amazed by the accomplished result.

John became a pupil at Henry Sass's Art Academy in Bloomsbury. His first studies included drawing from casts in the neighbouring British Museum as well as visits to the newly opened National Gallery where he saw works by masters including Rembrandt, Rubens and Titian. Millais won a silver medal awarded by the Society of Arts for his drawing *The Battle of Bannockburn* when aged only nine. So jealous were his older fellow students of his precocity and

this achievement that they suspended him from a window head down, from where he was rescued in an unconscious state. Millais's family was highly supportive of his *métier* and they constantly encouraged him, his father even making props and his mother historical costumes for his models.

On 17 July 1840, at the age of eleven, Millais entered the prestigious Royal Academy Schools as its youngest-ever student. He was initially a Probationer, but was enrolled as a full Student six months later. He was known there as 'the Child', a nickname that remained with him into adulthood. He embarked on six years of study, the teaching method placing great emphasis on drawing (he did not attempt to paint in oil until 1841, when he produced his *Cupid Crowned with Flowers*). In 1843 Millais won a silver medal for drawing from antique sculptures. A year later he met the seventeen-year-old William Holman Hunt at work drawing in British Museum, encouraging him to submit his own work to the Royal Academy, and entering a lifelong friendship with him. Within two years, Millais's first major painting, *Pizarro Seizing the Inca of Peru*, which had been painted when he was still only sixteen, was shown at the Royal Academy summer exhibition.

On the strength of this early triumph, Millais was commissioned to paint decorations for the Leeds home of John Atkinson. He also entered the competition to design decorations for Westminster Hall with a gigantic canvas depicting *The Widow's Mite*. He became a member of a drawing group called the Cyclographic Club, along with Hunt and another near-contemporary, Dante Gabriel Rossetti. The following year Millais won a gold medal for his religious painting *The Tribe of Benjamin Seizing the Daughters of Shiloh*, for which his brother William sat for the male figures.

The year 1848 was marked by revolutions in Europe and by Chartist demonstrations in England, demanding parliamentary reforms and rights for the common people. At this time, Millais was sharing his Gower Street studio with Hunt. There he completed *Cymon and Iphigenia*, a work based on John Dryden's translation of a poem by Boccaccio, while Hunt worked on his *Eve of St Agnes*. It was during the course of their work and discussions with like-minded friends that Millais formed the Pre-Raphaelite Brotherhood together with Hunt and Rossetti, along with Rossetti's brother William Michael, Frederic George Stephens, Thomas Woolner and James Collinson. Among their shared aims was a return to the style of fifteenth-century Italian masters and a concern with painting directly from nature, an aspiration derived in part from the theories expounded in John Ruskin's *Modern Painters*, the first two volumes of which had been published in 1843 and

SIR JOHN EVERETT MILLAIS

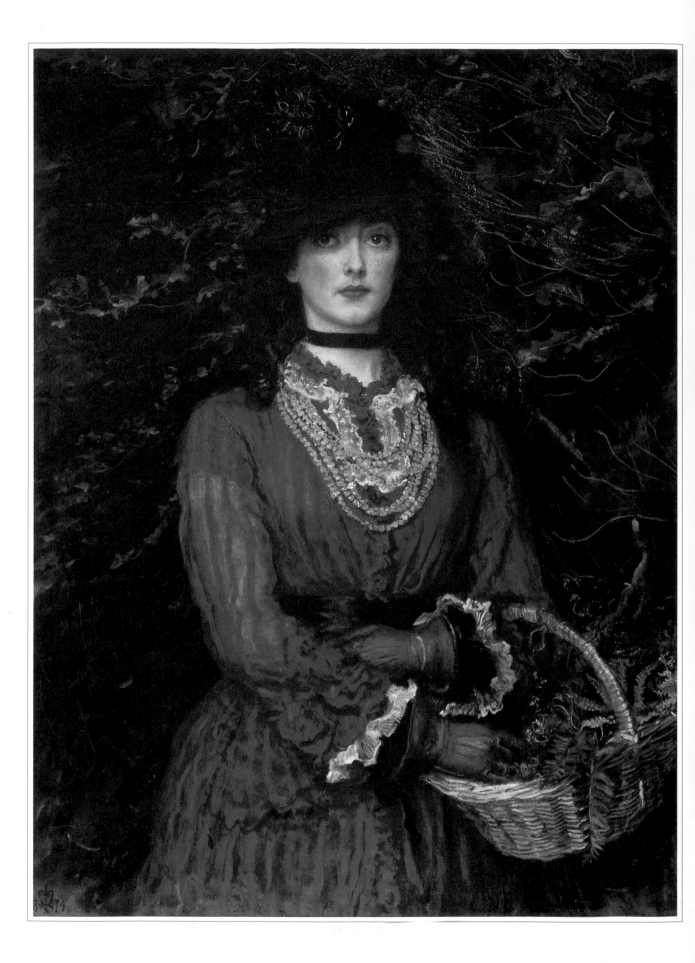

1846. Millais immediately began to paint in the new style. His first exhibited Pre-Raphaelite work, and the first to bear the then-secret 'PRB' initials, was *Isabella*.

In 1849 Millais began a series of portrait commissions from the Wyatt family (James Wyatt already owned *Cymon and Iphigenia*). His *Isabella* was well received at the Royal Academy, and during the summer he painted the Oxford background to *Ferdinand Lured by Ariel*, the head of Ferdinand modelled by F. G. Stephens. In the same year Millais also executed his curious gothic drawing *The Disentombment of Queen Matilda*, and, while Rossetti painted his *The Girlhood of Mary Virgin*, adopted his own religious theme with *Christ in the House of His Parents*, which was subjected to a vituperative attack by Charles Dickens and from the press of the day. He also embarked on *The Return of the Dove to the Ark* and *Mariana*, based on Tennyson's poem of twenty years earlier. Millais's Wyatt portraits and *Ferdinand Lured by Ariel* were exhibited at the Royal Academy but were scorned by critics. He concentrated on the landscape backgrounds for his *The Woodman's Daughter*, which, with *Mariana* and *The Return of the Dove to the Ark*, was exhibited in 1851 at Royal Academy, but to a poor reception.

Having received repeated critical attacks and being appalled by the vast crowds thronging to London for the Great Exhibition of that year, Millais was now at an emotionally low ebb, and needed all the encouragement he could secure. Ruskin, a hero of the Pre-Raphaelite Brotherhood, provided its members with powerful support through two letters published in *The Times*. Hunt and Millais wrote to thank him, in consequence of which John and his wife visited Millais in his studio, inviting him back the same evening to supper at their Park Street home. Millais had met Mrs Ruskin seven years earlier when, at the age of sixteen, he had attended a dance at Ewell Castle, the Surrey home of Captain William Lemprière, a fellow Jerseyman. She was then Effie Chalmers Gray, a girl of seventeen. Now she was married to John Ruskin, Britain's foremost art critic, who was both wealthy (he was the son of a successful sherry importer) and influential. Effie was a member of a large Scottish family, the daughter of lawyer George Gray and his wife Sophia, one of fifteen children, and a distant cousin of Ruskin. They had known each other since she was twelve and he twenty-one and, despite the opposition of Ruskin's parents, had married on 10 April 1848. The wedding took place at the Grays' home, Bowerswell, near Perth, Scotland.

For reasons, or excuses, of Ruskin's devising, which ranged from not wishing to have children and not wanting his bride's health to be damaged by pregnancy, neither on their wedding night nor on the nights which followed was the marriage consummated. The Ruskins' union was unconventional, even by the puritanical standards of the day. Ruskin was in all probability a manic depressive with a catalogue of psycho-sexual problems, among which he appears to have been horrified to discover that, unlike the classical statues with which he was familiar, his virgin bride had pubic hair. Ruskin's phobias and the abstinence upon which he continued to insist caused severe tensions which, being unable or unwilling to understand, he claimed derived from Effie's mental instability.

On 4 August 1851 the Ruskins returned to Venice, the city in which they had previously spent a year while John Ruskin worked on his monumental book *The Stones of Venice*. There, largely ignored by him, the vivacious and popular Effie had many suitors, but remained entirely faithful to her neglectful husband. After their return to

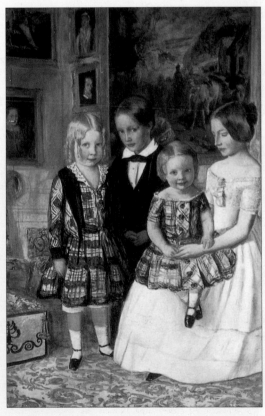

The Wyatt children, the subjects of Millais's first portrait commissions.

England, she found her social activities severely restricted and she was compelled to spend time with Ruskin's dour family, who had paid for a house near their own.

Millais spent the summer of 1851 in Kingston painting landscapes with Hunt, and producing *The Bridesmaid*. The next year Millais had Elizabeth Siddal, later Rossetti's wife, sit (or rather, lie) for him as *Ophelia*, which was considered a great critical success, and painted *A Huguenot*, which was even more popular, and was his first painting to be published as an engraving. He worked too on *The Proscribed Royalist*, with fellow Pre-Raphaelite Arthur Hughes posing for the head of the title subject.

In 1853 Millais became friendly with John Leech, the principal cartoonist of the humorous magazine *Punch*. Leech was a keen sportsman whom Millais often accompanied on foxhunting expeditions. In that year, now back in England, Effie Ruskin's constrained life with her husband was relieved when Millais asked her to model for him in *The Order of Release* at his Gower Street studio. The 'release' from the tensions of her relationship with John and his parents may have been accidental, but it was certainly an apt title. This work was exhibited at the Royal Academy together with *The Proscribed Royalist*.

As the friendship between Millais and the Ruskins developed, John Ruskin invited Millais, along with his brother William, to spend a working holiday with them in Scotland. The party stayed first at an inn and then at a schoolmaster's cottage in Glenfinlas, where Millais embarked on a portrait of Ruskin standing on rocks with a waterfall behind, a project that presented many difficulties. Ruskin worked on a speech to be delivered in Edinburgh

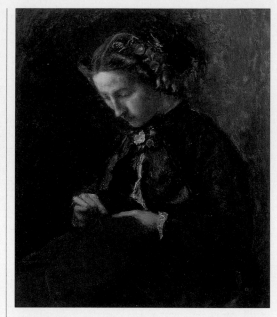

Effie with Foxgloves [in] Her Hair, painted b[y] Millais in 1853.

Drawings from Millais's fateful holiday at Glenfinlas: *Two Masters and their Pupils* shows Effie (the 'pupil') with Millais, one of the 'masters' of the title (the portrait of the second master, Ruskin, was cut out after Effie's marriage to him ended). *Awful Protection Against Midges* highlights a hazard of painting that even masks and cigarette smoke did little to alleviate.

and on the massive index for *The Stones of Venice*, publishing the first of three volumes later that year. When not engaged on the troublesome portrait, Millais devoted himself to fishing and producing numerous drawings, while he became increasingly attached to Effie. In contrast to her serious-minded

husband, Effie must have found the young artist amusing and attractive – he was over six feet tall and very slim, an enthusiastic sportsman and, as contemporaries observed, exceptionally strong and agile. Millais gave Effie drawing lessons and during the time they spent alone together she gradually revealed to him details of her marriage, to which Millais responded with a sympathetic ear. As his affection for his mentor's wife grew, Millais wrote to Hunt (who had also been invited on the trip, but had declined), 'Today I have been drawing Mrs Ruskin, who is the sweetest creature that ever lived.' Millais called her 'the Countess', having heard a servant address her thus, and she called him 'Everett', to distinguish him from the other John, her husband John Ruskin. Millais painted numerous sketches, with Effie present in almost all, and executed a sensitive oil study of her with foxgloves in her hair.

Although it was intended for Ruskin, Millais held on to this portrait as a keepsake of their memorable trip and of his love for Effie.

Millais left Glenfinlas on 28 October. Back in London in November, he learned of his election as the youngest-ever Associate of the Royal Academy. The following day Rossetti, ever the most faithful to Pre-Raphaelite principles, wrote in a letter to his sister, the poet Christina Rossetti, '... so now the whole Round Table is dissolved.' Her own response was to write a sonnet outlining the break-up of the group. The

Pre-Raphaelite Brotherhood had lasted just over five years. Before the year was out, Millais had written to Effie's mother, who was made aware of her daughter's unhappy situation, and expressed his concern for her well-being.

Effie consulted her friend Elizabeth Eastlake, the wife of Charles Eastlake, President of the Royal Academy from 1850, and the daughter of an obstetrician, who seemingly gave her advice about the sexual aspects of marriage previously largely a mystery to her. Effie then wrote to her father explaining her predicament, urging her parents to travel to London and confront Ruskin. On legal advice, the Grays did not meet with him, but arranged for her to leave Ruskin on the pretext that she was visiting them in Scotland. On 25 April 1854, just after the sixth anniversary of her wedding to Ruskin, Effie left their home and travelled to her family's house in Scotland, never to return. Her wedding ring and keys were delivered to Ruskin and legal action was commenced to annul the marriage. At this time, civil courts did not deal with annulment cases, and the matter was duly placed before an ecclesiastical court. When the issue was made public, the scandal eclipsed even news from the Crimea, where war had just broken out. In a well-orchestrated campaign, Elizabeth Eastlake ensured that Ruskin was clearly established as the sole cause of their marital misery. The circumstances of the Ruskin–Millais scandal have been clouded by the partisan accounts of the participants and their respective supporters, and by the censoring and destruction of correspondence relating to the affair, so we shall probably never know for certain that the blame was entirely Ruskin's. However, the later lives of Effie and of Ruskin make it clear that while she had no apparent impediments to settling to normal married life, Ruskin certainly did. Millais's own part in the affair led to many a rumour, including his being banned from the Royal Academy, but the truth was that he was so emotionally disturbed that he could neither bring himself to finish the vexed portrait of Ruskin, nor anything else. Effie was examined by doctors who testified to her virginity, after six years of marriage to Ruskin. By July the case had been heard and her annulment was granted on 15 July 1854, the Decree of Nullity stating the marriage to be void because '... John Ruskin was incapable of consummating the same by reason of incurable impotency.'

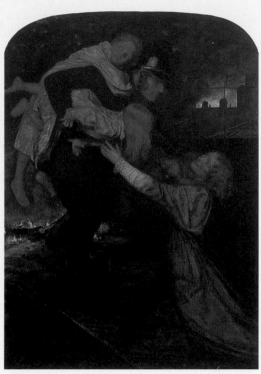

Despite these events, Millais doggedly returned to work on Ruskin's portrait, and on learning of the annulment, wrote to Effie remarking, 'This time last year there seemed no more chance of what has happened than that the moon should fall.'

Millais went to Winchelsea in Sussex to paint the background for *The Blind Girl*. Also in 1854, he received a commission to provide illustrations for the so-called 'Moxon Tennyson' (an elegant edition of Tennyson's poems published by London bookseller and publisher Edward Moxon). The Pre-Raphaelite Brotherhood had published four issues of a periodical, *The Germ*, to which Millais and others had contributed engravings. He continued to undertake illustrative work during the 1850s and 1860s, working for six years on *The Parables of Our Lord*, and supplying illustrations for periodicals, including *Once a Week*, as well as realistic scenes of Victorian life for the novels of Anthony Trollope, who became a close friend. Millais's biographer Marion H. Spielmann noted the exceptional quality of his line work: 'His drawing was irreproachable – subtle and suggestive, as well as firm and correct; his line and composition were almost inspired; his black and white has never been excelled.'

He finally finished the hated Ruskin portrait by December 1854 and delivered it. Ruskin told him that he hoped they could remain friends in spite of events – a forlorn hope as Millais made abundantly clear to him.

In January of the following year Millais was inspired by an event he witnessed in the early hours of the morning while returning from a ball in Porchester Terrace. Noticing a glow in the sky, the artist and his brother William asked their cab driver to head in that direction. On arrival at the scene they saw two firemen with a hose standing on a rafter, silhouetted in black against the flames. Suddenly there was an appalling shout as the rafter collapsed into the building below, taking the two men with it. Millais felt compelled to honour these brave and noble men on canvas and decided that the painting would be ready for the 1855 Royal Academy exhibition. After spending almost eighteen months on the Ruskin portrait, Millais executed this, his first contemporary painting, in just three. On hearing that *The Rescue* was complete, Ford Madox Brown noted Millais's remarkable speed of execution, in his diary of 11 April 1855, remarking, '... three weeks ago he had more than half uncovered, they say. How he does it I can't tell.'

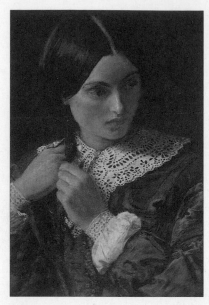

Only a Lock of Hair
(1857–58).

Millais was outraged when, after his exhaustive work, the picture was hung above eye level at the Royal Academy, too high to be fully appreciated. He described his anger in a letter to Hunt: 'I almost dropped down in a fit from rage in a row I had with the three hangers, in which I forgot all restraint and shook my fist in their faces, calling them every conceivable name of abuse.' *The Rescue* was lowered by the three inches that Millais demanded, after his threatening to resign from the Royal Academy, the Pre-Raphaelites basking in the rebellion of their colleague. William Michael Rossetti praised *The Rescue* in his 'Art News from London' column in the American periodical *The Crayon*, declaring the painting to be '... beyond compare the great picture of the exhibition ... his most wonderful and consummate work.' The work was also generously praised by Ruskin, who in spite of everything remained objective about Millais's work, later describing him as, among the Pre-Raphaelites, '... always the most powerful of them all'. *The Rescue* was later exhibited in Paris where it was well received.

Effie, who had resisted seeing Millais until February 1855, granted him a brief visit at her Scottish home, and it was agreed that they would marry that summer. Millais spent the evening of 9 June celebrating his coming nuptials at a party organized by Wilkie Collins, the son of a landscape painter and later famed as the author of *The Moonstone* and other popular novels. Afterwards, Millais travelled to Effie's family home and quickly became accepted as a much-loved future son-in-law. On 3 July Millais and Effie were married. As with her marriage to Ruskin, the couple honeymooned in Scotland, before embarking on what was to become a blissful marriage of more than forty years. Ruskin, on the other hand, regressed further and later became infatuated with a ten-year-old girl by the name of Rose La Touche, to whom he proposed marriage. Rose's mother wrote to Effie, who explained how unsuitable a husband Ruskin would make. He became increasingly deranged, dying in 1900.

The newly wed John and Effie Millais divided their time between Annat Lodge, Perth, near Effie's family residence, Bowerswell, and London, where Millais had a studio at Langham Place. On 30 May 1856 their first child Everett was born. Artistically and financially it was a good year: Millais's two masterpieces

Sketch for
The Black Brunswicker
(1859–60).

The Blind Girl and *Autumn Leaves* were completed, and they and *Peace Concluded* were sold for the then substantial total of 2,000 guineas (£2,100). *A Dream of the Past – Sir Isumbras at the Ford* followed in 1857, and was exhibited at Royal Academy, achieving both acclaim and adverse criticism, becoming the victim of a parody by Frederick Sandys. Millais painted *Pot Pourri*, and continued working on *Apple Blossoms*, which he started at Annat Lodge in 1856 and completed in 1859.

Their second child George was born in 1857. Effie and Millais had a large family of four boys and four girls, which was a source of joy to him – and which provided models for many of his paintings. In late autumn they moved to York Terrace, Regent's Park. The next year was marked by the birth of their third child and first daughter, Effie, and, for financial reasons, a move back to Scotland, where *The Vale of Rest* was painted. The late 1850s represent a transitional period in Millais's work, from his Pre-Raphaelite technique to a freer style, with – for him – almost sketchy works such as his small portrait study, *Only a Lock of Hair* (1857–58).

In 1859 *Apple Blossoms*, *The Vale of Rest* and *The Love of James I of Scotland* were exhibited at the Royal Academy.

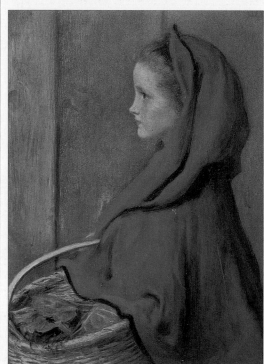

Red Riding Hood
(1864), a portrait
Millais's daughter
Effie.

Millais's principal painting of 1860 was *The Black Brunswicker*, which featured Kate Dickens, Charles Dickens's daughter, held in the embrace of a dashing officer (Millais's son and biographer John Guille Millais was at pains to explain that at no time did Miss Dickens and the male model actually come into direct physical contact). Its instant success marked Millais's return to popularity, while

his growing family and financial pressures led him to paint increasingly sentimental and popular subjects. He left the laborious methods of Pre-Raphaelitism behind as he moved to subjects with a ready market. He felt obliged to defended himself against accusations of 'selling out', writing in a letter to Hunt, 'A painter must work for the taste of his own day. How does he know what people will like two or three hundred years hence? I maintain that a man should hold up the mirror to his own times. I want proof that the people of my day enjoy my work, and how can I get this better than by finding people willing to give me money for my productions?'

In 1862 Millais moved back to London, to a house at 7 Cromwell Place, South Kensington, but from then onwards made an annual visit to Scotland. There he could relax from the pressures of his more 'commercial' subjects and paint landscapes at a leisurely pace, and could take time off for fishing and stag-hunting, two pursuits that he followed with great passion.

Among Millais's notable paintings of the early 1860s were *Trust Me* (1862) and *The Eve of St Agnes* (1863), which were followed in 1863 by *My First Sermon*, an avowedly sentimental subject featuring as model his daughter Effie. In the same year he was elected as a Royal Academician. *My First Sermon* began a long series of similarly sentimental images of attractive children, especially small girls and boys, with works such as his *Girl with a Doll* (a portrait of Lily Noble) of 1864, *Leisure Hours* and *Red Riding Hood* (both 1864), *Cinderella* (1881) and, perhaps most notably,

A Souvenir of Velázquez (1868), Millais's Royal Academy Diploma painting.

Bubbles (1886). He also made a speciality of historical subjects featuring children, with such paintings as *The Boyhood of Raleigh* (1870), *The Princes in the Tower* (1878), *Princess Elizabeth in Prison* (1879), which features his daughter Sophie, and *The Girlhood of St Theresa* (1893). Among other characteristic themes are those of courting couples and contemplative women as in *Yes or No?* (1871).

By the 1870s portraits of women had become an increasingly important part of Millais's repertoire, featuring both named individuals such as *Mrs Bischoffsheim* (1873), *Miss Eveleen Tennant* (1874), *Louise Jopling* (1879), *Miss Beatrice Caird* (1879) and *Dorothy Thorpe* (1882). He also continued to use members of his own family, such as his daughter Alice, who was the model in *The Picture of Health* (1874) and *The Crown of Love* (1875), as well as society ladies, as the casts of genre paintings including his acclaimed *Hearts are Trumps* (1872). To these he added lucrative formal portrait commissions of such eminent personages as Disraeli, Tennyson and Henry Irving.

The success of *My First Sermon* led to *My Second Sermon*, which similarly had the younger Effie as its model. Other works featuring children at sleep and awakening continued with, in 1867, *Just Awake*. One Sunday Millais found a

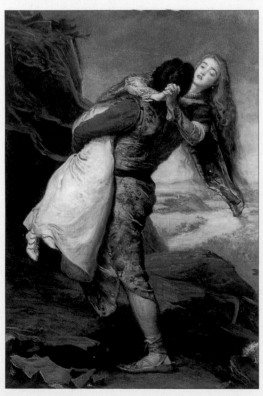

The Crown of Love (1875), depicting Millais's daughter Alice.

Millais's portrait of Benjamin Disraeli (1881), painted only months before the former Prime Minister's death

pretty child sitting near him in church and asked her parents for permission to allow her to sit for *A Souvenir of Velázquez*, his 1868 Diploma work for the Royal Academy (the painting presented to the Academy by an artist in commemoration of his election as an Academician).

The Boyhood of Raleigh of 1870 became one of the most famous history paintings and, with later narrative pictures by Millais, familiar to generations ever since from countless reproductions in children's books and prints on school walls. *Chill October*, also dating from 1870, was his first major Scottish landscape and one of his greatest landscape masterpieces. In the same year, Millais drew Dickens as he lay on his deathbed. *The Knight Errant* of 1870 was one of Millais's rare sorties into the type of medieval chivalric subjects popular with Rossetti, Burne-Jones and Pre-Raphaelite followers such as John William Waterhouse. Its associated work, *The Martyr of the Solway*, was first shown in 1871. *Victory, O Lord!*, which Millais completed in 1871, is a rare biblical subject but lacks the earnestness of Hunt's religious works. According to F. G. Stephens, 'Mr Millais has had this picture in hand during several years past; it does him great honour, and redounds to his credit more than many of his recent works.'

According to Millais's son John Guille Millais, *A Yeoman of the Guard* of 1876 was one of the

artist's favourite paintings and, like his *The North-West Passage* of 1874, appealed to patriotic sensibilities. In 1875 Millais had been commissioned by a dealer to paint a huge canvas depicting Beefeaters undertaking their traditional search of the Houses of Parliament prior to the beginning of a parliamentary session, a work never executed. However, the artist visited the Tower of London to study the guards' uniform and was inspired by their colour and style. Believing that the impact of such a vibrant hue would be diminished by artificial light, Millais opted for a single figure in the open air. He sought a model distinguished enough to suit their costume, and found a retired Yeoman Warder, Major Robert Montagu, who sat for the head and hands. The frail Major, then over eighty, found the sittings very exhausting and had to be sustained by soup every forty-five minutes. Millais painted at great speed, completing his work in just a few days. Marion H. Spielmann wrote warmly of 'The effect of the flesh, neither executed by recipe nor concealed by overpainting', and also noted that the '... management of scarlet, gold and blue – a striking yet not forced harmony – is among the fine things in modern Art.' Despite his limited financial means, the painting was bought by Millais's half-brother Henry Hodgkinson, who also owned *Pizarro Seizing the Inca of Peru* and *The Woodman's Daughter*. He was so delighted and proud to own the painting that he left it to the nation in his will, much to Millais's approval.

In the same year, 1877, Millais painted *Effie Deans*, described by Millais's son as '... one of Millais's most successful pictures in the field of romance'. Inspired by Sir Walter Scott's 1818 novel *The Heart of Midlothian*, the subject depicts the lovers Effie Deans and George Staunton parting in King's Park, Edinburgh. The models were

Arthur Gwynne James, the nephew of Lord James of Hereford (who also posed as the Master of Ravenswood in Millais's other Scott-inspired painting of the same year, *The Bride of Lammermoor*), with Lillie Langtry as the heroine. The next year Millais painted a sensitive portrait of Lillie Langtry under the title *A Jersey Lilly*. Millais's chief work of 1878, *The Princes in the Tower*, was highly praised at the Paris International Art Exhibition, where the artist was awarded the gold Medaille d'Honneur and created Officer of the Légion d'Honneur, a triumph overshadowed by the death of Millais's son George from tuberculosis.

Millais was enormously prolific, painting more than 400 oils in his lifetime. He was hugely energetic and hard-working, yet he managed to find time for educational, charitable and public work, instituting reforms to Royal Academy teaching methods, establishing the Artists' Benevolent Institution with architect Philip Hardwick, and devoting a great deal of energy to promoting the establishment of the National Portrait Gallery in 1889 and encouraging Sir Henry Tate to found the Tate Gallery in 1892. He received numerous accolades in the form of awards and honorary doctorates, and earned increasingly large sums from the sale of his works and of copyright for the production of popular prints. *Cherry Ripe*, an avowedly sentimental subject with which Millais was nonetheless unhappy, was sold to the *Graphic* in 1879. The magazine issued a print of the work as a Christmas supplement, selling a remarkable 600,000 copies. At his peak Millais earned up to £40,000 a year – an enormous amount by nineteenth-century standards, and one that would today put him in the millionaire bracket. His prosperity was made publicly manifest when in 1878 the Millais family moved to 2 Palace Gate, Kensington, a sumptuous neo-classical house designed for him by Philip Hardwick, the son of the architect of Euston Station. Most of the successful painters of the day had grand houses, some, such as those of Leighton and Alma-Tadema, verging on the palatial. Their 'At Homes', at which the distinguished visitors might include the Prince of Wales or Richard Wagner, were part of London social life, with as many as 500 visitors attending an open day (often to the industrious Millais's chagrin). Millais's new establishment was so grand that when visited by Thomas Carlyle (whose portrait Millais painted), he was awestruck, asking, 'Has paint done all this, Mr Millais? It only shows how many fools there are in the world.' In 1881 Millais also took the tenancy of Birnham Hall, Murthly, in Perthshire, thus establishing stately bases in both London and Scotland.

The Liberal leader William Ewart Gladstone sat at Millais's new studio for his portrait in 1879, reportedly revelling in his brief respite from the stresses of political life (he was painted again on subsequent occasions), as did Benjamin Disraeli shortly before his death in 1881 (the last letter he wrote was to Millais). Cardinal Newman sat in the same year and also the Marquis of Salisbury in 1883. In 1885 Gladstone conferred an hereditary baronetcy on Millais, who became the first-ever artist to receive such a high honour. He took the title Baronet of Palace Gate, Kensington, County Middlesex and St Ouen, Jersey, in remembrance of his Channel Islands roots. In that same year, Millais painted *The Ruling Passion (The Ornithologist)*. The ornithological theme featured in this work appears elsewhere in Millais's oeuvre, as in his *Cuckoo* (1880), *Dropped from the Nest* (1883) and *The Nest* (1887).

An exhibition of Millais's collected works was held at the Grosvenor Gallery, London, in 1886, the catalogue containing extracts from Ruskin's varied critiques from the 1850s to 1870s. Edward Burne-Jones wrote to Millais to tell him that visiting the show had '… impressed me, excited me and revived me beyond words.' In that same year Millais produced *Bubbles*, perhaps his most famous though often ridiculed work, and harked back to his earlier historical subjects, most especially *A Huguenot*, with his *Mercy – St Bartholomew's Day, 1572*.

Millais continued to make his annual visits to Scotland, and to paint fine landscapes, such as his *Glen Birnam* (1891), but his formerly robust health was showing signs of failing. In March 1892 he suffered a bout of influenza which hindered his usual output. His illness was exacerbated by a series of exceptionally heavy London fogs, and it was discovered that he had the first symptoms of throat cancer.

He visited the seaside resort of Bournemouth in 1894 in an attempt to recover his strength, and the next year, in the absence of President of the Royal Academy Lord Leighton, who was also ill, addressed the Academy, despite the obvious distress this caused to his throat. A summer spent yachting off Jersey and an autumn visit to Bowerswell did little to alleviate his declining health, and his completion in 1895 of the doom-laden *Speak! Speak!* was hindered by his weakened state. Millais had had the subject in mind for at least twenty-five years. His son John Guille explained the subject, 'A young Roman has been reading through the night the letters of his lost love … at dawn, behold the curtains of his bed are parted, and there

before him stands, in spirit or in truth, the lady herself, decked as on her bridal night ... An open door displays the winding stair down which she has come.'

Leighton died on 25 January 1896, and although Millais was himself terminally ill, he insisted on attending the funeral. Millais succeeded Leighton as President of the Royal Academy on 20 February, whereupon he received a witty letter from his old ally Hunt who remarked, 'You have gone a letter higher – from PRB to PRA.'

At the time of the annulment of her marriage to Ruskin, all Effie's friends had rallied round and supported her, but the strict social etiquette of the day had meant that the merest hint of the scandal attaching to an annulled marriage or divorce caused her to be ostracized at gatherings Queen Victoria might attend, a restriction on their otherwise busy social life which irritated Millais until – almost literally – his dying day. Appeals to the Queen explaining the circumstances of the affair, and Effie's unblemished character, were in vain, and Effie was compelled to remain at home as her husband chaperoned her daughters to debutante balls, a pattern that continued even after Millais had become famous, wealthy, and had been elevated to the baronetcy. As Millais lay dying, however, Queen Victoria sent a message via an equerry asking if there was anything she might do for the artist. He wrote on slate, 'I wish Her Majesty the Queen would see my wife.' After more than forty years of snubbing her, the Queen immediately agreed to receive Effie, who was herself in declining health and now virtually blind, and so she travelled to Windsor Castle to go through the simple but significant ceremony of curtseying to the Queen Empress.

Millais died at home on 13 August 1896 at the age of sixty-seven. Holman Hunt and the actor Sir Henry Irving were among the pall-bearers at his funeral, which took place a week later in the crypt of St Paul's Cathedral. On 7 September the following year Millais's son Everett died of pneumonia, and Effie died on 23 December. She was buried at Kinnoull Church, Perth, the churchyard featured in her husband's 1858 painting, *The Vale of Rest*.

A memorial exhibition of Millais's works was held at the Royal Academy in 1898, and in 1899 his devoted son John Guille Millais published his two-volume *The Life and Letters of Sir John Everett Millais*, which he dedicated 'To the Memory of my Dear Father and Mother'.

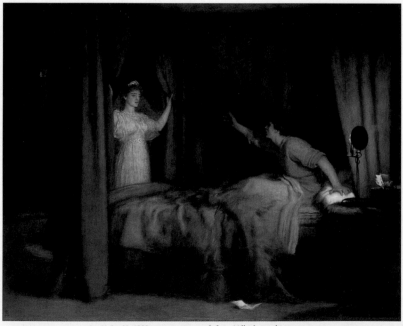

Speak! Speak! (1895), a portentous work from Millais's penultimate year.

THE PLATES

PIZARRO SEIZING THE INCA OF PERU
———————— 1846 ————————

Oil on canvas, 50 1/2 × 67 3/4 in / 128.3 × 172.1 cm
Victoria & Albert Museum, London

This was Millais's debut painting exhibited at the Royal Academy. Derived from a sketch Millais is said to have made on the back of a cheque, the finished work was painted when the artist was only sixteen, but immediately established his reputation, his biographer Marion H. Spielmann noting, '... he was recognized as a marvel and all stood astonished at his work.' The following year Millais was awarded a gold medal for the painting by the Society of Arts. The work depicts the Spanish conquest of Peru at the moment on 16 November 1532 when Francisco Pizarro, the Spanish leader, seizes the Peruvian ruler Atahualpa at Cajamarca. This event led to the slaughter of thousands of Indians by Spanish soldiers. The conquest did indeed occur at sunset, and Millais used this symbolically to represent the twilight of the Inca empire. A Catholic priest, Vincente de Valverde, brandishing a crucifix, almost obscures the disappearing sun. On the right of the composition, a mother with her child quotes the Massacre of the Innocents. History paintings were very popular at the time and Millais may have been influenced by seeing Henry Perronet Briggs's 1826 work, *The First Interview between the Spaniards and the Peruvians*, which was on public display (and is now in the Tate Gallery). The artist would also have seen Sheridan's play *Pizarro* in early 1846 at the Princess Theatre, a venue he often frequented. The actor James William Wallack played the Indian hero Rolla on the stage and was recast by Millais as Pizarro for his painting. Valverde was modelled by the artist's father, John William. Millais may have borrowed costumes and props from the Princess Theatre, although his fellow Pre-Raphaelite painter Holman Hunt said that Millais was lent these by the artist Edward Goodall who had recently returned from a visit to South America.

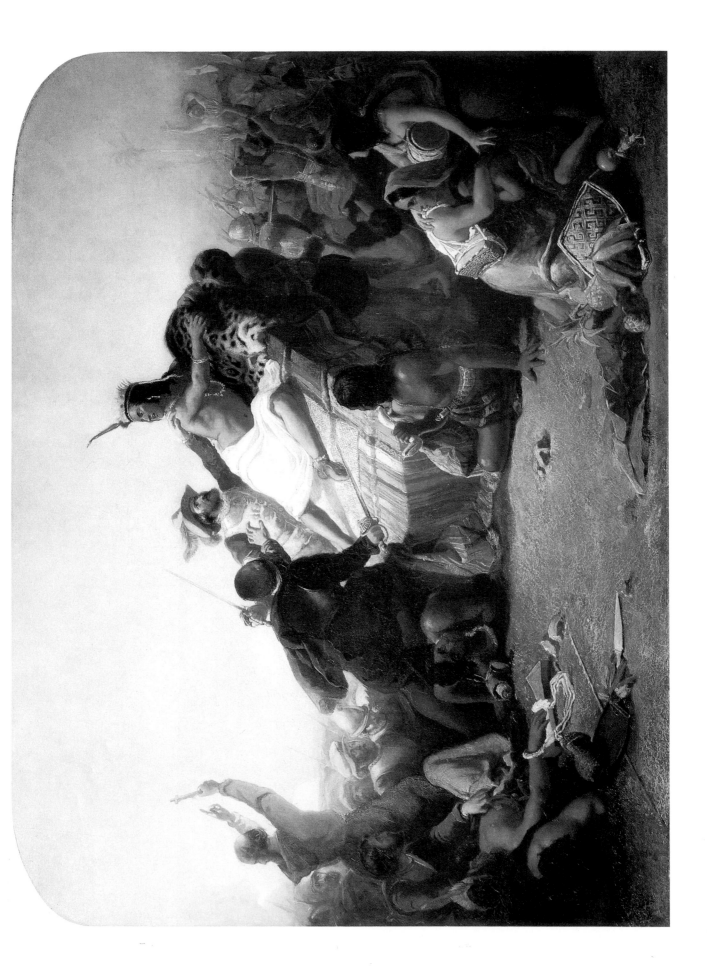

CYMON AND IPHIGENIA
—————— 1848 ——————
Oil on canvas, 45 × 58 in /114.3 × 147.3 cm
Private collection

The story of Cymon and Iphigenia came from Boccaccio's *Decameron*. Cymon was a simple but handsome swain who fell in love with the beautiful and more refined Iphigenia. They eventually married and he became a sophisticated gallant. Millais's painting is based on lines from John Dryden's translation of the story:

> Then Cymon first his rustick Voice essay'd,
> With proffer'd Service to the parting Maid
> To see her safe; his Hand she long deny'd,
> But took at length, asham'd of such a Guide;
> So Cymon led her home.

The subject was very much part of the art-historical canon, having been painted by such masters as Rubens, Lely and Reynolds, and later by Leighton. However, artists traditionally depicted the scene in which the rugged Cymon discovers the sleeping beauty. Stylistically, the painting was very much influenced by William Etty, the most revered contemporary figurative painter. Holman Hunt, with whom Millais worked at this time, executed some of the drapery in return for Millais's help on his *The Eve of St Agnes*. In early April 1848 this painting was entered for the Royal Academy summer exhibition, but was rejected as unfinished. In 1849 the Oxford art dealer and collector James Wyatt, whose portrait Millais later painted, bought the painting for £60. In 1852 the owner permitted the artist to retouch the sky, some foliage and drapery, and this is particularly apparent in the foreground where a greater degree of Pre-Raphaelite detail is apparent. After Wyatt's death in 1853, the painting was sold at Christie's and made an important feature in the catalogue. It was bought for 350 guineas by George Wyatt, James's second son, who took it home to his home in Newport on the Isle of Wight.

PLATE 3

ISABELLA

——— 1849 ———

Oil on canvas, 40 1/2 × 56 1/2 in /102.9 × 142.9 cm
National Museums & Galleries on Merseyside (Walker Art Gallery)

This was the first major painting to bear the controversial 'PRB' – Pre-Raphaelite Brotherhood – initials. They featured twice, in fact, alongside Millais's signature and in the carving on the side of Isabella's stool, despite which they seem to have gone unnoticed. The work had been started when Millais was nineteen – '... the most wonderful painting that any youth under twenty years of age ever did in the world', according to Holman Hunt. Hung at the Royal Academy next to Hunt's *Rienzi*, *Isabella* (as it was originally titled, although it is sometimes known as *Lorenzo and Isabella*) resulted in a barrage of abuse, though critics were divided. The painting, executed in the early gothic stage of Pre-Raphaelitism, received acclaim for its early Italian, particularly Florentine style. The source of the costumes was Camille Bonnard's *Costumes Historiques*, which had been published in 1829; Isabella's specifically came from an illustration of Beatrice d'Este by Paul Mercuri. The unusual perspective and awkward composition show a conscious affront to academic conventions, which the *Art Journal* felt '... cannot fail to establish the fame of the young painter'. The models for the composition were mostly friends and relatives of Millais, although their identities have been much disputed. The man with the napkin is the artist's father. The art critic Frederic George Stephens sat for the brother holding up the glass, with the American-born artist Walter Howell Deverell to his left in profile. A friend, Jack Harris, is seen on Stephens's right, kicking the dog, and William Hugh Fenn (the subject of a portrait by Millais) peels an apple, while Dante Gabriel Rossetti sits at the back drinking. Lorenzo was modelled by both William Michael Rossetti and Charles Compton and Isabella by Mary Hodgkinson, the wife of Millais's half-brother. The identity of the servant is uncertain, though it may have been either an architect named Wright or a Royal Academy student called A. F. Plass. Alluding to ill-fated love, the painting depicts a passage from Keats's poem 'Isabella or the Pot of Basil', based on a story by Boccaccio:

> Fair Isabel, poor simple Isabel!
> Lorenzo, a young palmer in Love's eye!
> They could not in the self-same mansion dwell
> Without some stir of heart, some malady;
> They could not sit at meals but feel how well
> It soothèd each other to be the other by.

Isabella fell in love with Lorenzo, an employee of her brothers, who were enraged at her choice. Here one of her malevolent brothers raises his glass sarcastically whilst another kicks her dog. This cruel motif, courageous for a British artist to depict, was criticized in the *Athenaeum* as an 'absurd mannerism'. The lovers are shown sharing a symbolic blood orange. Between them lies a majolica plate decorated with a biblical decapitation scene, probably Judith and Holofernes. Later in the story Isabella's brothers murder her lover and bury him in the forest, explaining away his disappearance to their distraught sister. Lorenzo appears to Isabella as a ghost and reveals his tragedy. Isabella then exhumes the body, decapitates the head and plants it in a large pot of basil – in Millais's painting the balcony is prophetically decorated with plant pots. When Isabella's brothers discover what is contained in the pot of basil, they flee with Lorenzo's head, leaving Isabella to die of a broken heart. By 1849 the painting was owned by Benjamin Godfrey Windus, but according to Hunt the picture was bought by three Bond Street tailors for £150 plus a suit. This implies they were William Wethered, who was also an art dealer, with his friends Colls and Wass, the three men who bought William Etty's *Joan of Arc* in 1847.

PLATE 4

JAMES WYATT AND HIS GRANDDAUGHTER
———— 1849 ————

Oil on panel, 14 × 17 ¼ in / 35.6 × 45.1 cm
Private collection

James Wyatt (1774–1853) had met Millais by 1846 when the artist painted a watercolour of his grandchild Mary and then bought *Cymon and Iphigenia*. Wyatt was a dealer and collector of art as well as being a print publisher, and was Mayor of Oxford in 1842–43. On the strength of his earlier purchase, Wyatt commissioned several small-scale family portraits, which show the transition in technique from Millais's early painting to his evolving Pre-Raphaelite style. A contemporary critic wrote, 'The infinite patience and imitative skill in draughtsmanship, the brilliancy of execution, and the power of reproducing the brightness of sunlight, have manifestly been acquired before the lesson had been learned of harmonious effect and of subordinating the parts to the whole ... This portrait ... is unflinchingly true ... it has all been set down with pitiless and remorseless solicitude. The quaint little Dutch doll-like child has received the painter's most earnest attention.' On the left is a miniature portrait of James's father Frederick Wyatt and in the top right corner a portrait by Sir William Boxall of Eliza Wyatt, James's daughter-in-law, who Millais painted as a companion to this portrait.

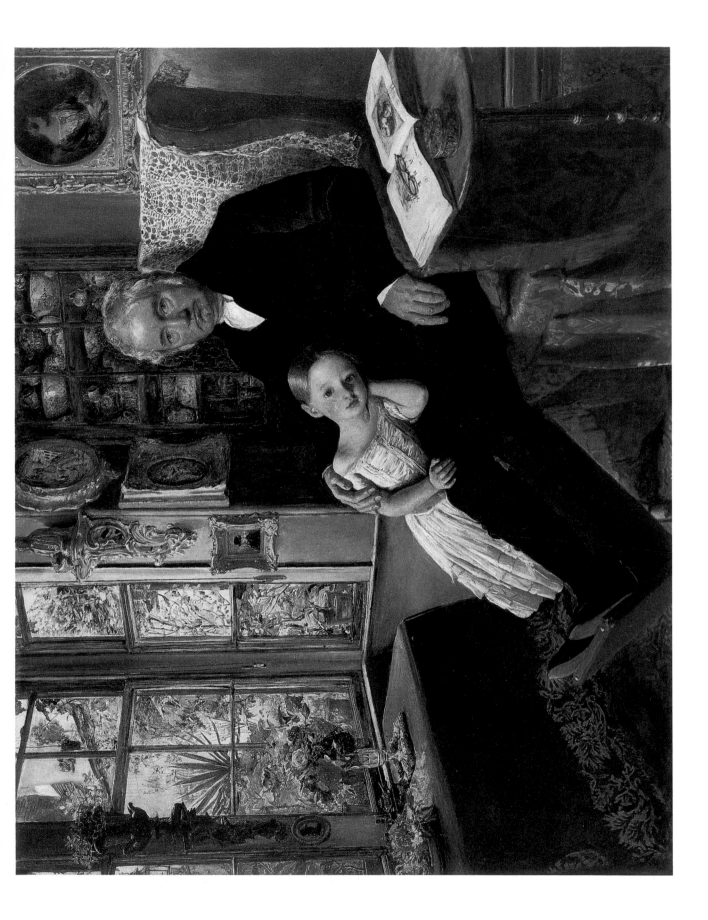

MRS JAMES WYATT AND HER DAUGHTER SARAH

————————— *c.1850* —————————

Oil on panel, 13¾ × 17¾ in / 354.9 × 45.1 cm
Tate Gallery, London

This small-scale double portrait was painted as a companion piece to *James Wyatt and his Granddaughter*. It was probably executed when Millais stayed near the Wyatts in the summer and autumn of 1850, while he was working on *The Woodman's Daughter* and *Mariana*. Eliza Wyatt, née Moorman (1813–95) was James's daughter-in-law. Sarah, later Mrs Thomas, was born on 17 January 1849, so was around twenty months old when this picture was painted. Some family notes give the date of the painting as around 1853; however this is unlikely as the child in the picture is clearly much younger than four years old. On the wall behind the figures are three prints: Leonardo da Vinci's *Last Supper* of 1495, Raphael's *Madonna della Sedia* of 1514 and his *Alba Madonna* of 1511. The latter two are similarly depictions of motherhood, but Raphael's loving mothers are idealized, in contrast to Millais's stiff and cold Mrs Wyatt, who barely touches her child. Her disposition is similar to that of the holy family in Millais's *Christ in the House of His Parents* of the same era and reveals something of his taste for repressed Victorian propriety.

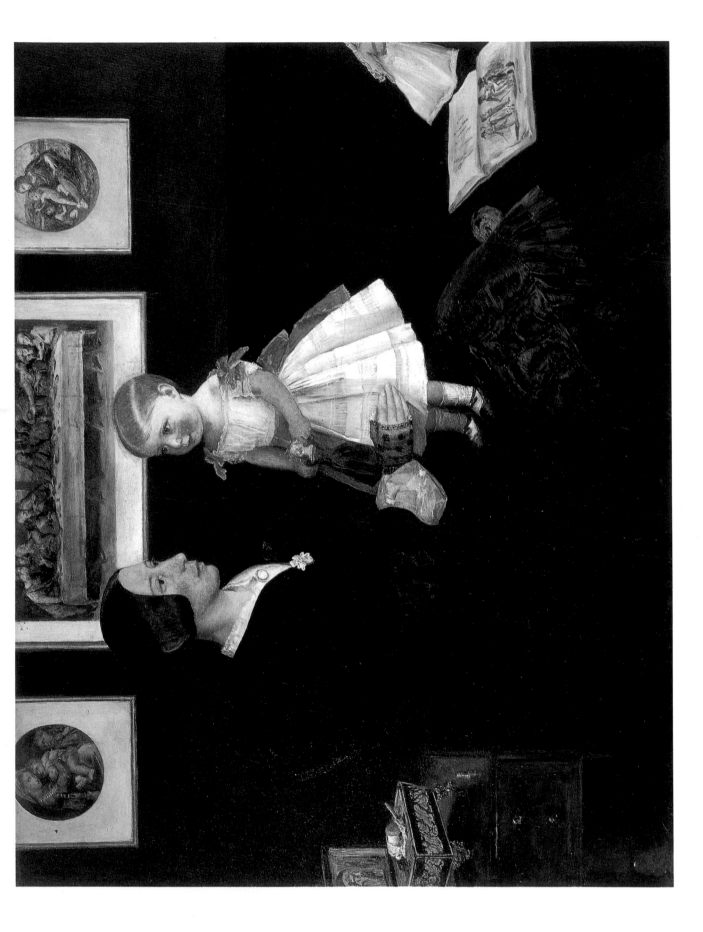

FERDINAND LURED BY ARIEL
————————— 1849–50 —————————

Oil on panel, 25 ½ × 20 in / 64.8 × 50.8 cm
The Makins Collection

The subject of this painting was taken from Shakespeare's *The Tempest*, in which Prospero's servant, the sprite Ariel, leads Ferdinand to his master. En route, Ariel teases Ferdinand about the death of his father, the King of Naples, in a shipwreck off Prospero's island. In the Royal Academy exhibition catalogue, the painting was accompanied by lines from the play. Here the sprite is carried through the air by surreal green bat-like creatures, holding a shell to prove his story. Ferdinand, modelled by the long-suffering F. G. Stephens, who had to endure a day-long sitting without a rest, stands in an odd pose, almost as if he is dancing. This was apparently derived, along with the design of his costume, from a plate entitled *Jeune Italien* dating from 1400 in Millais's much-used copy of Bonnard's *Costumes Historiques*. The luminosity of colour was obtained by the use of the Pre-Raphaelite 'wet white' technique, which consisted of applying paint to a freshly primed surface that was not allowed to dry. This was Millais's first attempt at *plein-air* painting. The background was executed in the summer of 1849 during a visit to a friend, George Dury, at Shotover Park in Oxfordshire. The landscape was meticulously depicted, Millais claiming, 'I have done every blade of grass and leaf distinct.' During the progress of the painting, the dealer William Wethered made some kind of commitment to purchase the picture, but subsequently withdrew the offer as a result of Millais's treatment of Ariel and the bats. Victorians were fascinated by fairies and no doubt Wethered expected a typically erotic sylph-like depiction of the sprite. Despite this rejection, Millais sold the painting prior to its exhibition for £150 to the collector Richard Ellison. Some time after Millais's death in 1896, but before it entered the Makins Collection, Hunt restored the painting as it had been what he described as 'ignorantly varnished'.

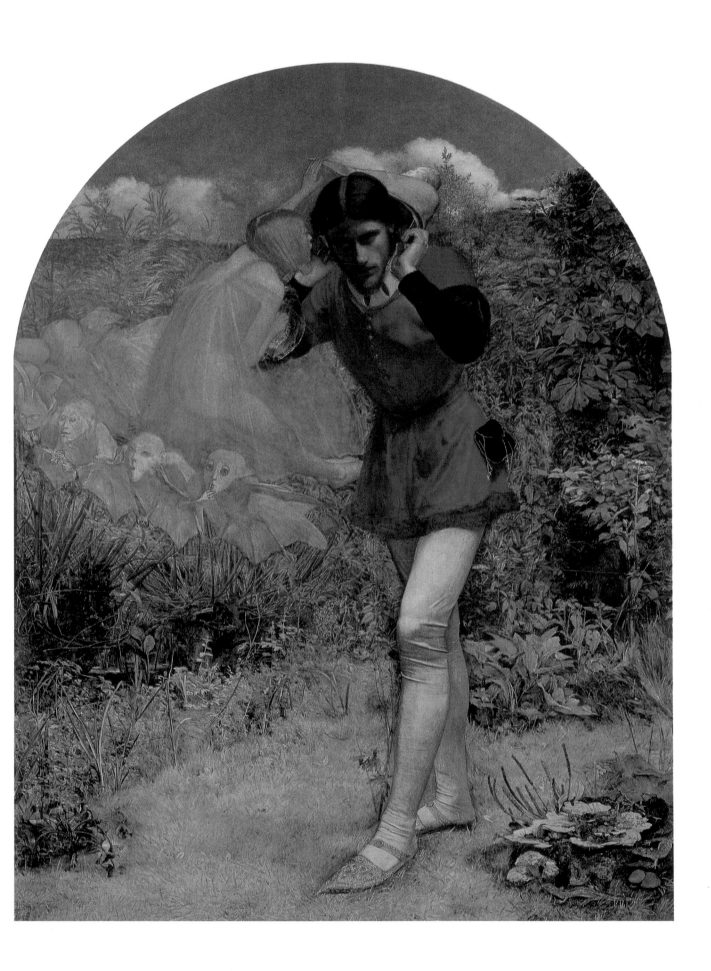

CHRIST IN THE HOUSE OF HIS PARENTS
(THE CARPENTER'S SHOP)

—————————— 1849–50 ——————————

Oil on canvas, 34 × 55 in / 86.4 × 139.7 cm
Tate Gallery, London

When this painting was exhibited in 1850, its contemporary audience found the graphic detail in the treatment of the biblical subject offensive and its warts-and-all treatment blasphemous. The critic in *Blackwood's Magazine* exclaimed, 'We can hardly imagine anything more ugly, graceless and unpleasant ... such a collection of splay feet, puffed joints and misshapen limbs was assuredly never before made ... We have great difficulty in believing the report that this unpleasing and atrociously affected picture has found a purchaser at a high price.' The painting was sold for £150 to dealer Henry Farrer and later to Thomas Plint, a Pre-Raphaelite collector who lived in Leeds. *The Carpenter's Shop* was shown with Hunt's *A Converted British Family*, but bore the brunt of abuse directed at the Pre-Raphaelite Brotherhood. It was so controversial that Queen Victoria had the painting removed from the exhibition for a private viewing. The holy family were meticulously depicted as ordinary people. Charles Dickens, who would later become an ardent admirer of Millais, was possibly the painting's most vociferous critic, finding it '... mean, revolting and repulsive'. It was accompanied by lines from the Old Testament Book of Zechariah, interpreted by theologians as pre-figuring Christ's passion, 'And one shall say unto him, what are these wounds in thine hands? Then he shall answer, Those with which I was wounded in the house of my friends.' The taut, Rossetti-inspired composition is loaded with elaborate and evocative biblical symbolism that is typical of the Pre-Raphaelites. The set-square refers to the Holy Trinity, while the white dove on the ladder is symbolic of the descent of the holy spirit from Heaven at Christ's baptism. The red flower represents Christ's blood and his crucifixion is prophesied by the wood, nails and stigmata imagery. The Virgin was modelled by Mary Hodgkinson, seen previously as Isabella, and described by Dickens as '... a woman so hideous in her ugliness that ... she would stand out from the rest of the company as a Monster in the vilest cabaret in France or in the lowest gin-shop in England.' Christ was based on Nöel Humphreys, the son of a medievalist book illustrator, who Dickens claimed was a '... hideous wry-necked, blubbering, red-haired boy, in a bed gown'. There was some historical precedent for depicting Joseph, here a composite of Millais's father's head and the body of an unknown carpenter, working at carpentry, although he was customarily accompanied by Mary sewing or spinning. Other biblical figures such as St Anne and St John the Baptist, modelled here by Edwin Everett, an adopted cousin of the artist, were rarely included. Millais, however, had undoubtedly seen Herbert's *Our Saviour, Subject to His Parents at Nazareth*, which was exhibited at the Royal Academy in 1847.

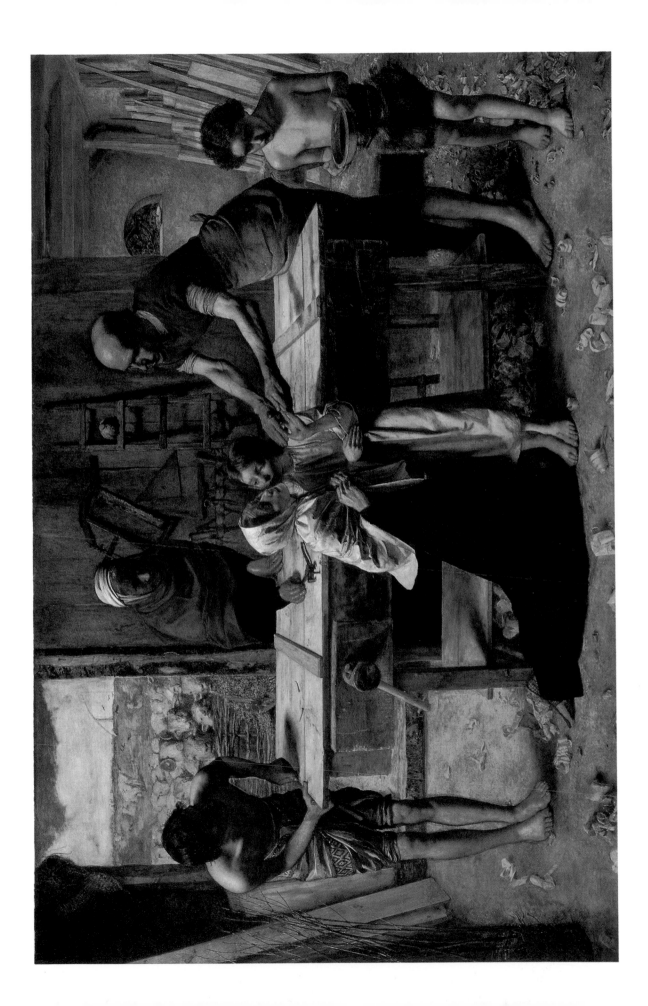

MARIANA

———— 1850–51 ————

Oil on panel, 23½ × 19½ in / 59.7 × 49.5 cm
The Makins Collection

Millais exhibited this painting with *The Woodman's Daughter* and *The Return of the Dove to the Ark*. It was then untitled but accompanied by lines from Tennyson's 1830 poem 'Mariana':

> She only said, 'My life is dreary,
> He cometh not,' she said;
> She said, 'I am aweary, aweary,
> I would that I were dead!'

Tennyson was one of the most popular poets of the Victorian era and had been made Poet Laureate in 1850; in 1857 Millais was to illustrate an edition of his poems. *Mariana* was in turn inspired by Shakespeare's *Measure for Measure*; in which the lonely heroine has spent five years in a moated grange after her marriage dowry was lost in a shipwreck. She was rejected by her lover Angelo with whom she was still in love. Eventually Mariana is reunited with the officious Angelo after he has become Deputy to the Duke of Vienna. Millais's languid Mariana, having been working on an embroidery, stretches with boredom. She looks out of a stained-glass window, based on the windows of Merton College Chapel, Oxford, depicting an Annunciation scene. This vignette of the Virgin's fulfilment provides a distinct contrast to Mariana's plight. The motto above translates as 'In Heaven there is rest', alluding to her suicidal inclinations at this point of the story. The heraldry was invented by Millais for its symbolism, the snowdrop signifying consolation; it is also associated with 20 January, St Agnes's Eve, when legend says women will have visions of their future lovers. The mouse in the bottom right corner is mentioned in Tennyson's poem. The small altar in the background holds a silver caster seen also in *The Bridesmaid* and *The Eve of St Agnes*. The garden, painted from Thomas Combe's Oxfordshire garden, is not faithful to Tennyson's poem which describes a gloomy view broken merely by a poplar tree. *Mariana* was bought for £150 just before its completion by the dealer Henry Farrer, who also bought *The Carpenter's Shop*. Farrer then sold it on to the collector Windus. The painting inspired Burne-Jones who visited Windus's house with William Morris: '... we saw ... a beautiful little picture of a lady in black by Millais ... and we came away strengthened and confirmed.' The dress, made from silks and velvets bought in London in December 1850, was actually deep blue, contrasting with the intensely vivid shades in the Rossetti-inspired stained glass. After being in the collection of Windus, the painting entered the collection of Henry Makins who requested Hunt to do some restoration work on it after Millais's death, as it had become dull.

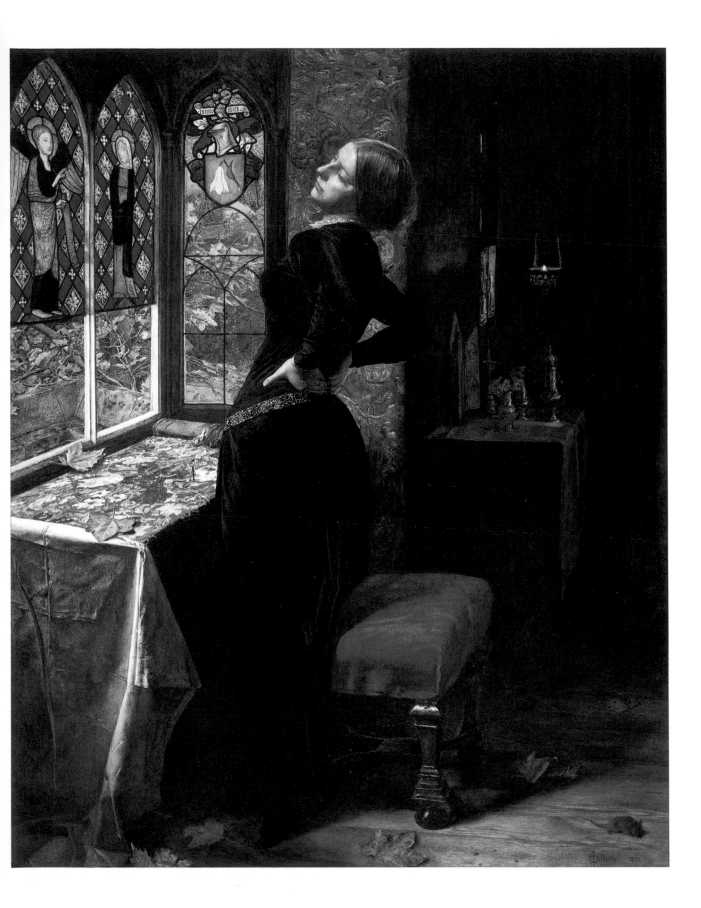

THE WOODMAN'S DAUGHTER
—— 1851 ——

Oil on canvas, 35 × 25 1/2 in / 88.9 × 64.8 cm
Guildhall Art Gallery, Corporation of London

Based on a poem of the same title by Coventry Patmore (1823–96), which appeared in his first volume of poems, published in 1844, *The Woodman's Daughter* refers to a relationship between Maud, the daughter of a woodman called Gerald, and the son of the local squire. Because of the difference in their social rank, they are thwarted in their desire to marry. Maud bears a child, which she drowns in a pond and goes insane. The painting illustrates the burgeoning of their childhood friendship:

> He sometimes, in a sullen tone,
> Would offer fruits, and she,
> Always received his gifts with an air
> So unreserved and free,
> That half-feigned distance soon became Familiarity.

The painting was 'assembled' from elements painted at different locations, from nature and in Millais's studio. Staying first with James Wyatt in Oxford, Millais moved to lodgings with a grocer called King at Botley from where he made excursions to Wytham Wood to paint the background for the painting. He asked Mrs Combe, a friend in Oxford, to buy the boots of Esther, a girl living in a lodge at the entrance to Lord Abingdon's estate, so that he could paint them as the woodman's daughter's footwear, also telling her, 'If you should see a country-child with a bright lilac pinafore on, lay strong hands on the same, and send it with the boots.' The strawberries proffered by the boy were purchased in Covent Garden market in March 1851. The models' identities are unknown. The painting was shown at the Royal Academy in 1851, but remained unsold until being acquired by Millais's half-brother Henry Hodgkinson. In 1886, at his request, Millais repainted parts of it, including the girl's face, which had been criticized by several observers, with results that are clearly visible on the canvas.

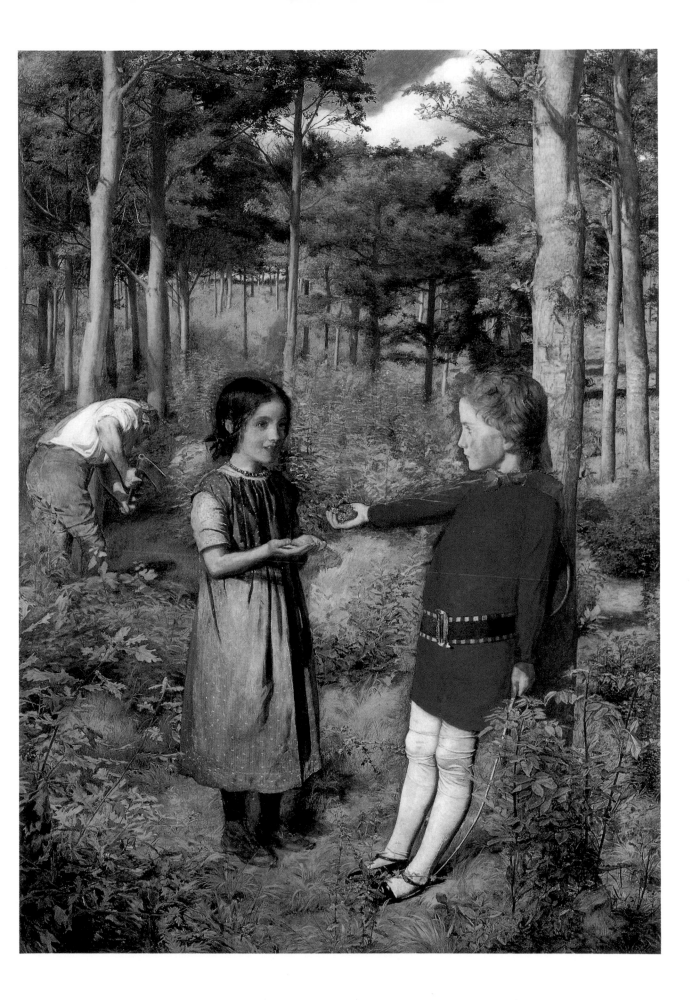

The Return of the Dove to the Ark
———————————— 1851 ————————————

Oil on canvas, 34 1/2 × 21 1/2 in / 87.6 × 54.6 cm
Ashmolean Museum, Oxford

This biblical painting from Genesis is related in subject to Millais's
The Eve of the Deluge and Charles Landseer's painting of the same title
exhibited in 1844, depicting one of Noah's wives holding the
returned dove to her breast. Millais had intended a three-figure
composition, including Noah, praying in front of a menagerie of birds
and animals. Noah and the animals were subsequently rejected some
time between February and April 1851. The painting was much
admired by Ruskin who apparently wished to purchase it, but Millais
had already sold it to his patron Thomas Combe. Millais always had
Combe in mind as a buyer for this picture as he wanted it to hang in
his prestigious collection with Hunt's *A Converted British Family*.
Millais and Pre-Raphaelite associate Charles Allston Collins had
stayed at Combe's home in Oxford, both painting portraits of their
patron and his wife's uncle William Bennet. Combe had bought
Collins's *Convent Thoughts*, which was close in dimensions to this
painting, with a complementary theme: hope contrasted by sacrifice.
Perhaps Millais intended his painting to be a pendant to his
colleague's, and for both of these to form a triptych with Hunt's
painting, thus representing three theological virtues, Faith, Hope and
Charity. The woman who holds the bird to her breast wears robes of
green, the colour of hope. Prior to sending the picture to its owner,
Millais advised Combe to hang the painting near a window, tilted
slightly forward to show it off advantageously.

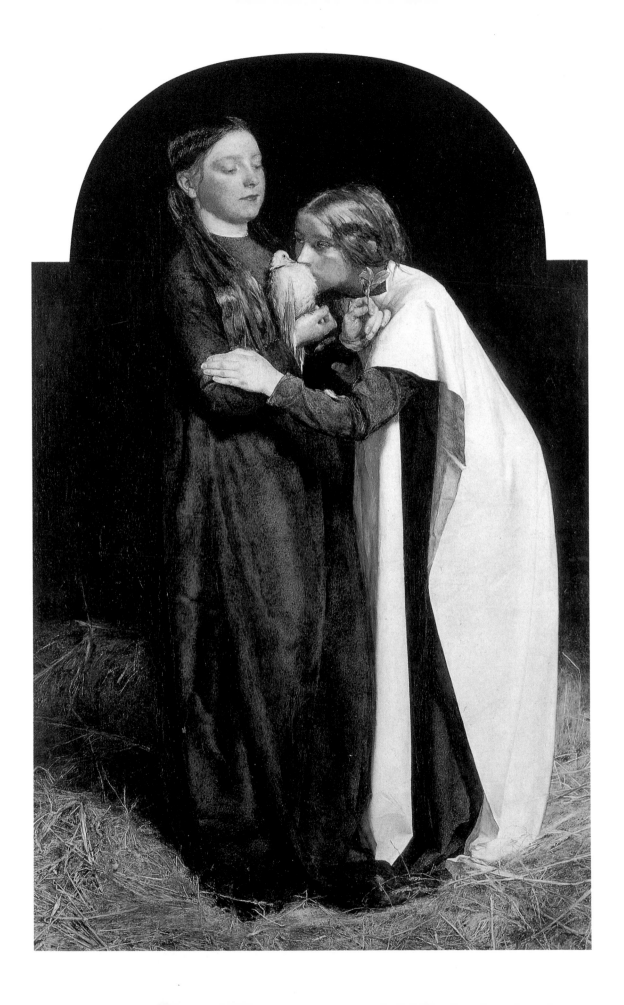

THE BRIDESMAID
——— 1851 ———
Oil on panel, 11 × 8 in / 27.9 × 20.3 cm
Fitzwilliam Museum, Cambridge

Millais depicts an old superstition which states that if a bridesmaid passes a small morsel of wedding cake through the wedding ring nine times, she will have a vision of her future lover. In this context, the painting is very much linked to both *The Eve of St Agnes* and *Mariana*, in which the same silver caster features. The girl's chastity is symbolized by the orange blossom at her breast, its colouring accentuated by the fruit and the shade of her hair. The symbolic flowers and fruit, as well as the luxuriant tenor of this painting, are reminiscent of Rossetti's sensual, half-length paintings of women of the same decade. The model, according to the *PRB Journal*, was a Miss McDowall. Millais depicted the same subject again in 1879, but on this occasion in very different style and content in a conventional portrait of his daughter Mary as bridesmaid to his eldest daughter Effie. This painting has often been variously but incorrectly entitled *The Bride* and *All Hallow's E'en*; *The Bridesmaid* was bought by B. G. Windus, who sold it as *The Bride* at Christie's in 1862. It is uncertain whether this Pre-Raphaelite collector was the first owner, though Ford Madox Brown definitely saw it in Windus's home in March 1855. In 1868 it was bought by Ernest Gambart, the foremost picture dealer in Europe.

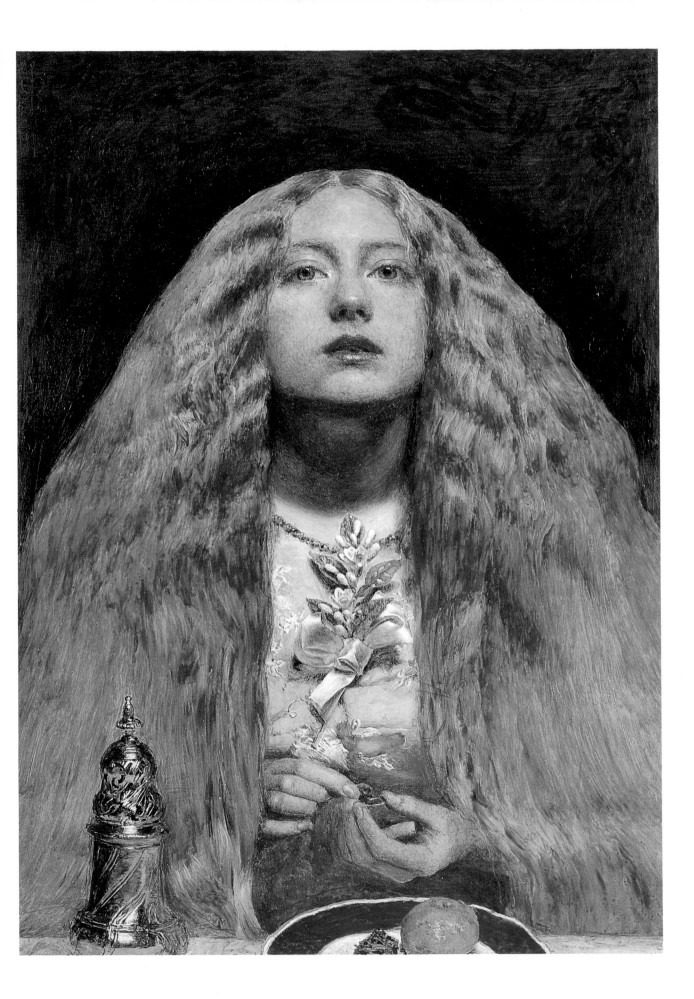

PLATE 12

OPHELIA
———— 1851-52 ————
Oil on canvas, 30 × 44 in / 76.2 × 111.8 cm
Tate Gallery, London

The subject of *Ophelia* was taken from Shakespeare's *Hamlet*, in which Ophelia's death is described by Queen Gertrude:

> There is a willow grows aslant a brook,
> That shows his hoar leaves in the glassy stream;
> There with fantastic garlands did she come ...
> When down her weedy trophies and herself
> Fell in the weeping brook. Her clothes spread wide,
> And, mermaid-like, awhile they bore her up;
> Which time she chanted snatches of old tunes.

It was innovative of Millais to depict this stage of the story where Ophelia, driven mad by her lover Hamlet killing her father, falls into a stream and decides to let herself drown. Much copied, *Ophelia* inspired Arthur Hughes's eerie painting of the same title exhibited in the same year. Fully clothed in what Millais described as 'a really splendid lady's ancient dress' for which he had paid £4, Dante Gabriel Rossetti's future wife Elizabeth Siddal modelled for Ophelia by laying in a bath of water heated by lamps below. She caught an extremely bad cold as a result of the lamps going out and her father threatened to sue Millais until he promised to pay her doctor's bills. Millais went to great lengths to achieve accuracy in the painting, taking four months to complete the figure alone. According to William Michael Rossetti, *Ophelia* was the best likeness of Lizzie Siddal. Ruskin wrote to the artist on seeing the painting during his first visit to the Royal Academy in 1852, 'I came home last night with only *Ophelia* in my mind and wrote to my son nearly as follows. Nothing can be truer to Shakespear [sic] than Mr Millais's *Ophelia* and there is a refinement in the whole figure – in the floating and sustaining dress – such as I never saw before expressed on canvas. In her most lovely countenance there is an Innocence disturbed by Insanity and a sort of Enjoyment strangely blended with lineament of woe.' The background was painted in a field belonging to Effie's friend Mr Gadesden on the River Hogsmill at Ewell in Surrey. There is a great deal of botanical accuracy, but the multitude of symbolic flora, which allude to Ophelia's situation, would not all have bloomed at the same time. Millais had originally used daffodils for touches of yellow until Tennyson advised that if combined with wild roses, it might be taken as meaning false hope. The willow alludes to forsaken love, as do the pansies which refer to an earlier scene of the play. The violets around Ophelia's neck, symbolic of faithfulness, are also referred to earlier in *Hamlet*. The nettle and daisy are symbolic of pain and innocence respectively. The death-symbol, the poppy, was not mentioned by Shakespeare, but was an addition by Millais. The robin is that from one of the songs she sings, 'For bonny sweet Robin is all my joy'. The purple loosestrife in the upper-right corner alludes to the 'long purples' in the play, although Shakespeare actually meant the purple orchid. On the left of the loosestrife, the meadowsweet represents the futility of her death. Ophelia's sorrow is symbolized by the pheasant's eye and the fritillary floating on the surface of the water. There was originally a water-rat in the composition, but Millais painted it out as it was deemed inappropriate for the melancholic mood of the scene. Beside the self-explanatory forget-me-nots, the chiaroscuro forms the outline of a skull, referring both to Ophelia's death and Hamlet's famous graveyard scene which follows.

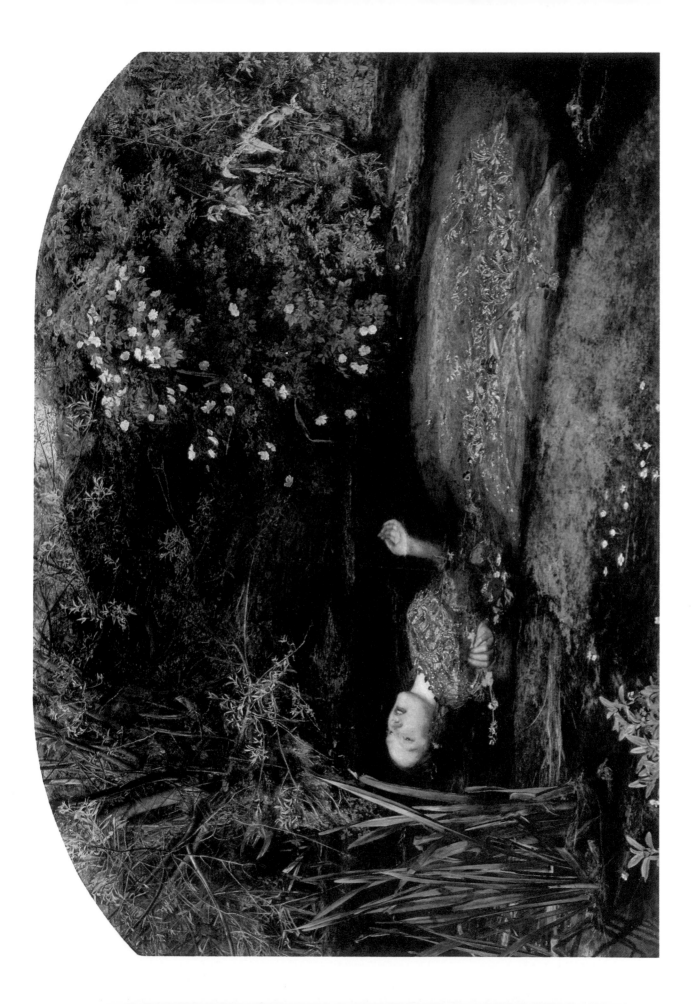

THE HUGUENOT
——— 1851–52 ———
Oil on canvas, 36½ × 24½ in / 92.7 × 62.2 cm
The Makins Collection

The Huguenot depicts an incident from the Massacre of St Bartholomew's Day. In August 1572 in Paris, French Catholics led by the Duke of Guise slaughtered thousands of Protestants, known as Huguenots. In another subject of ill-fated love, a Catholic girl attempts to prevent her Huguenot lover's death by persuading him to wear the white armband used to identify Catholics, but he is unwilling to compromise his principles even in the face of death. Millais was inspired by seeing the actress Pauline Viardot as Valentine in Giacomo Meyerbeer's opera *Les Huguenots* (1836), which was performed annually at Covent Garden after 1848. In it, after the Huguenot Raoul de Nangis refuses to deny his faith, his loyal lover Valentine converts to Protestantism and they marry, but both fall victim to the massacre. Huge crowds flocked to see this painting, probably due to its anti-Catholic implications, as there was much religious paranoia throughout Europe at this time. Millais embarked on the picture during his stay with Holman Hunt at Worcester Park Farm, originally intending to illustrate a line from Tennyson's poem 'Circumstance'. Hunt persuaded him that this was trite and Millais recalled the incident with the white cloth, applying it to his whispering lovers in a garden. Again he used symbolic flora: the ivy is symbolic of constancy or friendship in adversity, the Canterbury bells represent faith, and the nasturtiums, symbolic of patriotism, refer to Raoul's loyalty to his faith. Arthur Lemprière, the teenage son of Millais's friend William Charles Lemprière, modelled for the head of the Huguenot. The body was based on a professional model known as Child. Valentine was sat for by the beautiful model Anne Ryan, whose dark hair was changed to blonde. After being exhibited at the Royal Academy, *The Huguenot* was sent to Liverpool Academy where it was awarded a £50 prize. In March 1852 the picture and its copyright were purchased by the dealer D. T. White, who gave Millais £250 initially and then another £50 after the engraving was published. By April 1852 the painting had been acquired by his patron B. G. Windus. Millais was concerned about the deadening of colour tone in his paintings soon after their completion, and in January 1854 the artist Thomas Linnell advised him, 'I think the grounds you paint on must be too absorbent for I remember your saying that your picture of the Huguenot deadened in the same way and I have found that when a picture is painted on such ground it requires varnishing a good many times before it will bear out. I think you will find that all your pictures require is re-varnishing.' This good advice is attested by the lasting quality of Millais's paintings.

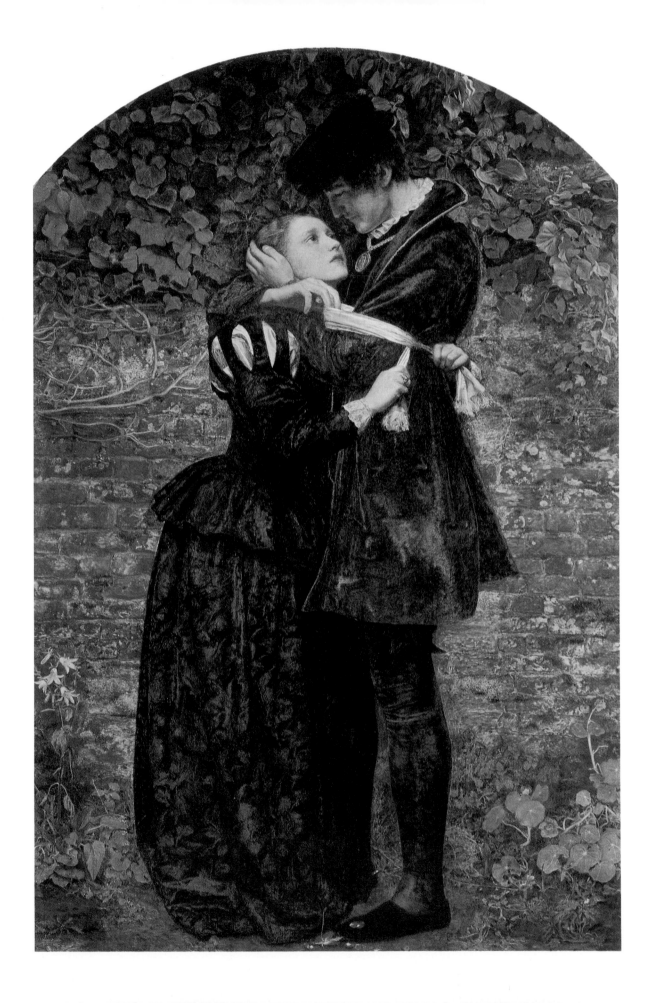

PLATE 14

THE PROSCRIBED ROYALIST, 1651

——————— 1852–53 ———————

Oil on canvas, 40½ × 28½ in / 102.9 × 72.4 cm
Private collection

Lewis Pocock, the Honorary Secretary of the Art Union of London, commissioned this painting in May 1852 for his own private collection. Desiring a subject of ill-fated love as in *The Huguenot*, the artist and patron had discussed a scene from *Romeo and Juliet*, particularly since Pocock had bought Shakespearean oil sketches by Hunt, although a Civil War context was eventually agreed upon. The couple here are from Vincenzo Bellini's 1835 opera *I Puritani*, which Millais saw at Covent Garden. She is Elvira, a Roundhead and he, Arturo, a Cavalier. The compositional device of hiding the young man in an oak tree, an emblem of valour, may have been inspired by the myth that Royalists avoided confrontation with their enemy by these means. The scene was painted from one of the most ancient trees on West Wickham Common, later known as the 'Millais Oak'. The artist stayed at The George Inn in Hayes near Bromley (for which he painted a new signboard), taking a week off to return to Gower Street to nurse a bad cold caught outdoors. Effie Ruskin was originally supposed to model for Elvira but was replaced by Anne Ryan from *The Huguenot*. Her period costume was painted from a dressed lay figure; the lace cuff, found for Millais by the ever-helpful Mrs Combe, was previously seen in *The Huguenot*. The artist's mother sewed the costume of Arturo, whose head was painted from Millais's friend Arthur Hughes.

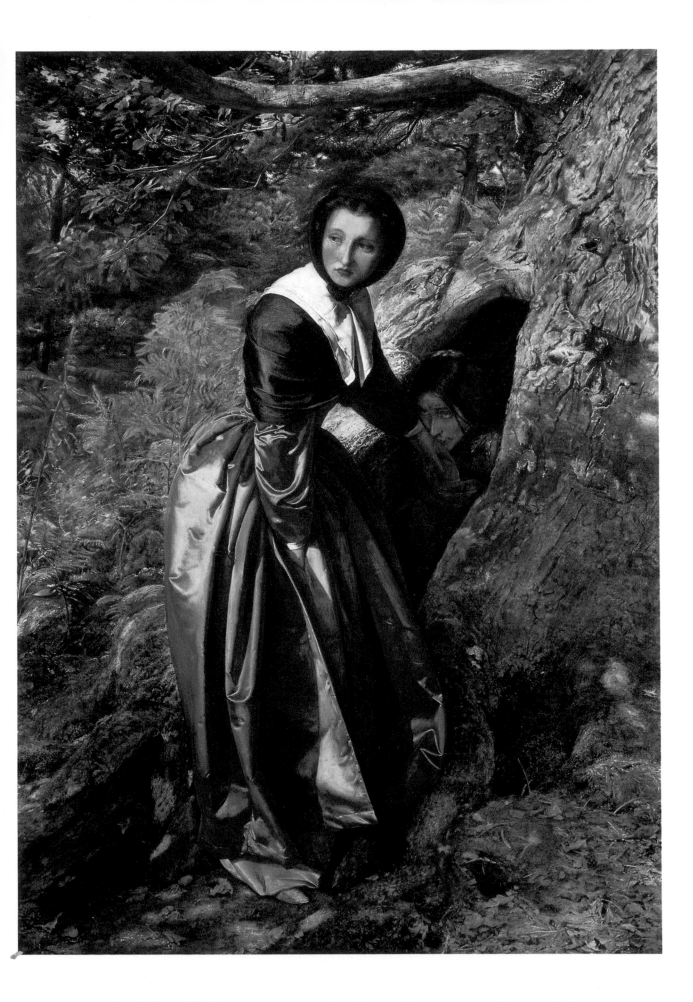

THE ORDER OF RELEASE, 1746

—————————— 1852–53 ——————————

Oil on canvas, 40 $\frac{1}{2}$ × 29 in / 102.9 × 73.7 cm
Tate Gallery, London

Originally entitled *The Ransom*, *The Order of Release* is set in a prison waiting-room. The work was probably entirely studio-painted as there is little reference to a setting, apart from the door. Millais had looked at the Tower of London for a suitable door or gateway, as well as researching churches, but was disappointed. Although the subject was invented by Millais, it was probably inspired by the novels of Sir Walter Scott. The rebel Scottish clansman, imprisoned after the defeat of Bonnie Prince Charlie at Culloden on 16 April 1746, is led by the jailer to his wife and child, dressed in the Drummond Tartan of the mother. His pet Collie jumps up at his master, its feet on his Gordon Tartan kilt. The Highlander was modelled by Westall, a deserter from a dragoon regiment who went on to become a famous model. He was later arrested in an artist's studio and imprisoned. When he had served his sentence, Westall was bought out of the army with funds raised by artists. Effie Ruskin modelled for the wife in the spring of 1853. Ironically, it was a prophetic picture for the artist and his female model, who was delighted to be released from her elderly in-laws, the Ruskins. Millais worked his model to an exhausting schedule from just after breakfast to nightfall with just one break for lunch. Effie wrote on the 20 March 1853, 'He found my head like everyone else who has tried it immensely difficult and he was greatly delighted last night when he said he had quite got it! He paints so slowly and finely that no man working as he does can paint faster.' John, the son of the artist and model, described it as a perfect likeness of his mother with the exception of her hair colour, since Effie's auburn locks were changed to black to contrast with those of the child. The primroses symbolize the child's youth and set the scene in spring. The woman's ambiguous expression implies that she prostituted herself to secure her husband's liberty, but despite her loss of virtue is self-possessed and has an inner strength. This was typical of the mid-nineteenth-century obsession with women's virtue. It was felt that virtuous wives and mothers were the very backbone of society and the key to British success. Effie was criticized for modelling by some of her then husband's friends who felt that this behaviour was inappropriate for a virtuous woman, but she believed it was justified as it was 'a painting of expression and of human sympathy and incident'. Millais found the child and dog to be very difficult models, 'All the morning I have been drawing a dog, which in unquietness is only surpassed by a child, both of these animals I am trying to paint daily, and certainly nothing can exceed the trial of patience they incur.' This controversial work required a police guard to control crowds at the Royal Academy. Andrew Lang wrote, 'As a piece of realistic painting it may challenge comparison with anything else in the world ... The work is saved by expression and colour from the realism of a photograph.' *The Order of Release* was bought by Joseph Arden, a lawyer friend of the novelist William Makepeace Thackeray, for £400; Arden also later bought *The Rescue*. In 1878 it was sold to James Renton for £2,853 and on Renton's death acquired by Henry Tate for £5,000.

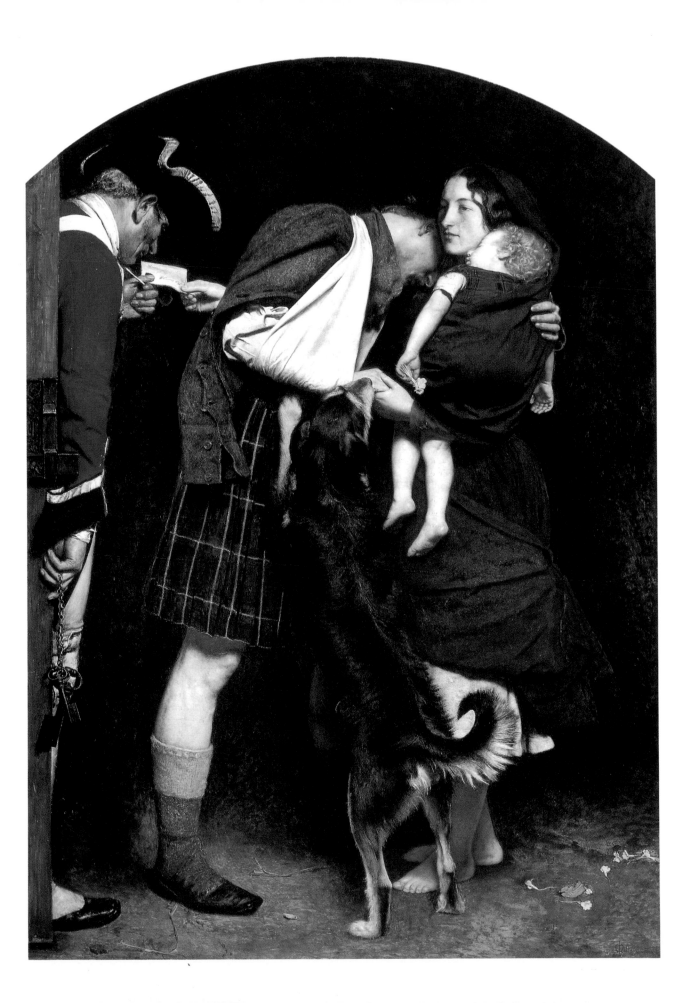

PLATE 16

JOHN RUSKIN
——— 1853–54 ———
Oil on canvas, 31 × 26¾ in / 78.7 × 68.0 cm
Private collection

Commissioned by the subject, this portrait by the river at Glenfinlas was begun in the summer of 1853. According to Ruskin, Millais had '... fixed on his place, a lovely piece of worn rock, with foaming water and weeds and moss, and a noble overhanging bank of dark crag ... I am sure the foam of the torrent will be something quite new in art.' The setting reflects the sitter's interests in geology and botany. Ruskin was trying to convert Millais to his style, providing preparatory studies of rock for the painting. The artist usually worked very fast but found this painting virtually impossible to execute, in March 1854 writing to Effie's mother, 'If only I had myself to consult, I should write immediately and refuse to go on further with the portrait, which is the most hateful task I ever had to perform.' Ruskin was seemingly unaware of Millais's distress, and in October wrote to his father, 'Millais has done some glorious bits of rock ... with all their lichens gleaming like frosted silver – most heavenly. He is delighted with it himself.' This discrepancy indicates that by this stage Millais was not wholly committed to the principles of Pre-Raphaelitism. After a break, and rather bizarrely, Millais suggested completing the waterfall in Wales rather than at the original site, but Ruskin insisted that the rocks were quite different and so Millais reluctantly returned to Scotland. The background was eventually finished in June 1854 and both artist and subject had to endure two further sittings. Millais was extremely relieved on the completion of portrait and received £350 in payment from the sitter's father. Ruskin was fairly pleased with the finished portrait, with the exception of a couple of small elements: he did not like the yellow flower and nor did he appreciate the sparkle in his right eye, 'making me slightly squint'. It was during this working holiday that Millais and Effie's relationship developed. The unconsummated marriage of Ruskin and Effie was annulled in 1854, and she married Millais the following year.

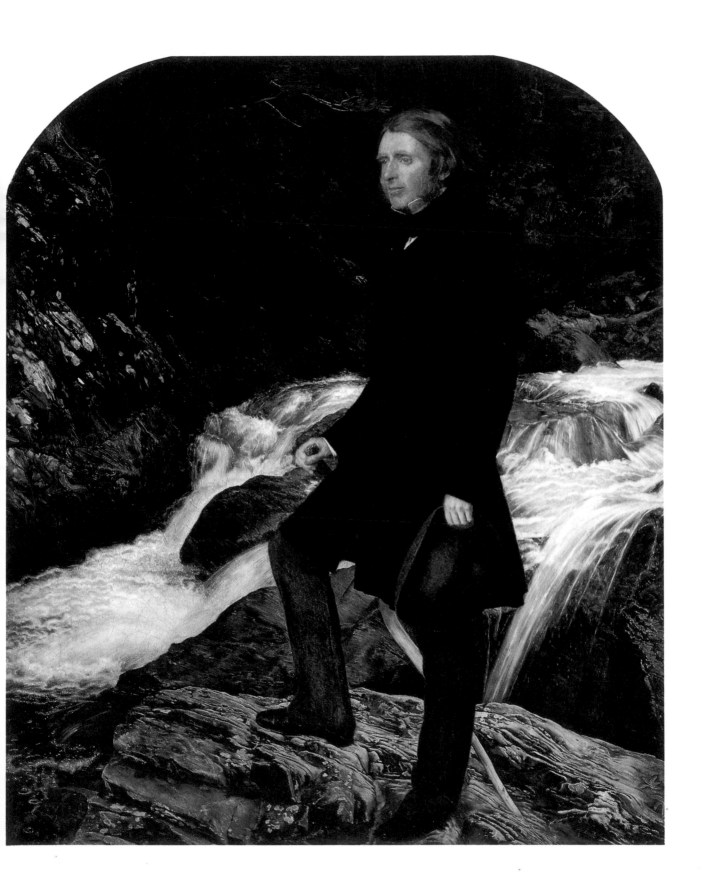

THE BLIND GIRL
——— 1854–56 ———
Oil on canvas, 32 ½ × 24 ½ in / 82.6 × 62.2 cm
Birmingham City Museums and Art Gallery

Perhaps Millais's most highly acclaimed painting, *The Blind Girl* was retrospectively considered by many critics as a key picture in British art, and a graphic justification of Pre-Raphaelite principles. Another simple composition without much symbolic meaning, it is a sensitive evocation of affliction and the contemporary social issue of young and disabled vagrants. It depicts a blind girl of about eighteen years old and a young female companion resting at the roadside as they wait for a shower of rain to pass. The models were Matilda Proudfoot (as the blind girl) and Isabella Nicol, two young girls from Perth seen also in *Autumn Leaves*. The background is believed to be a view of Winchelsea in Sussex from the East (though according to the artist's son, John Guille Millais, portions were painted at Barnhill near Perth). The melancholy mood is accentuated by the evocative landscape and leaden sky with the double rainbow and the thunder clouds. Rossetti described it as '... one of the most touching and perfect things I know'. The brilliance is for the benefit for the viewer's unimpaired eyes, making one's sympathy for the girl all the more poignant. Denied the beauty of such light, she is surrounded by objects that accentuate her other senses such as wet grass and forget-me-nots, and in her lap is a concertina, described by Ruskin as her '... poor instrument of musical beggary'. The concertina was lent by a Mr Pringle, whose daughter had died six months earlier, on the understanding that no one would play it. The girl's petticoat was originally red, but as it clashed with the other colours, it was replaced by a striped yellow and brown one that was still not ideal. Millais decided that he needed one in a shade of amber, and when Effie (to whom he was now married) saw a woman at her local butcher wearing one of the right colour she asked her poultry woman Jean Campbell to request its loan. Millais kept it for two days and his wife then returned the petticoat to the bemused woman along with a shilling. Ruskin celebrated the luminosity of Millaiis's palette: 'The freshly wet grass is all radiant through and through with the new sunshine; the weeds at the girl's side as bright as a Byzantine enamel, and inlaid with blue Veronica.' Not all contemporary critics were so favourable in their analysis: *The Times* condemned the painting as '... another study of red hair ... pretty obvious ... not very original', a pedantic writer in the *Art Journal* attacked the order of the colours in the rainbow and several influential Royal Academicians commented adversely. Millais was convinced of a conspiracy against him that resulted from innate jealousy, 'I have the whole Royal Academy (with one or two exceptions) against me.' The painting was sold to Ernest Gambart for 400 guineas with an additional 200 guineas for copyright as the painting was to be engraved.

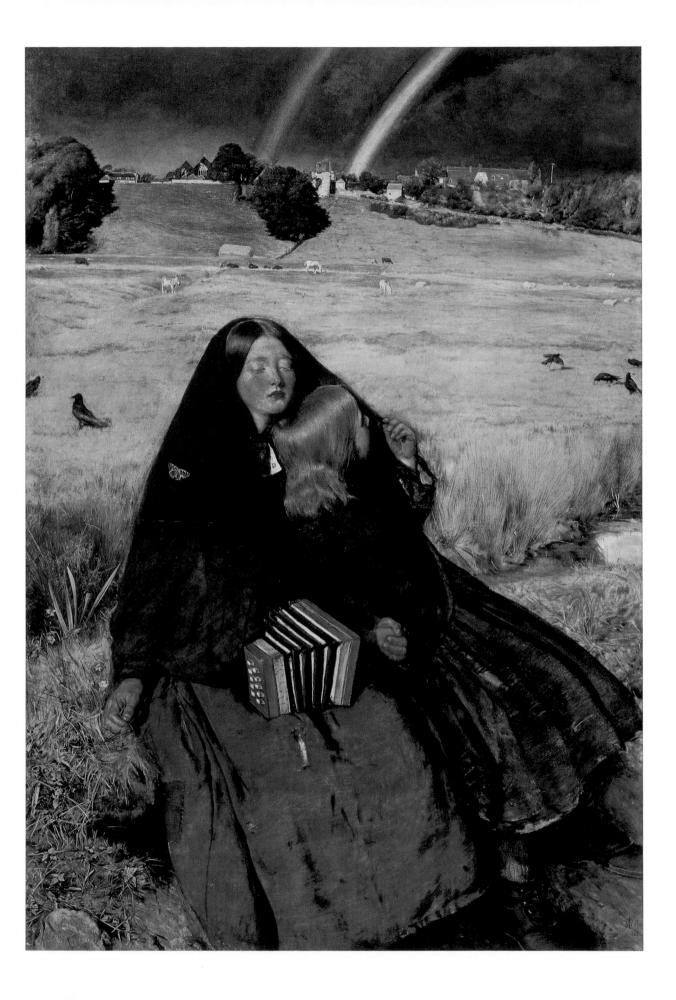

AUTUMN LEAVES
—— 1855–56 ——
Oil on canvas, 41 × 29 in / 104.1 × 73.7 cm
Manchester City Art Galleries

Four years prior to the execution of this painting, Millais asked, 'Is there any sensation more delicious than that awakened by the odour of burning leaves? To me nothing brings back sweeter memories of the days that are gone; it is the incense offered by departing summer to the sky, and it brings on a happy conviction that Time puts a peaceful seal on all that has gone.' The subject of this highly acclaimed picture was simple and unpretentious. It depicts four girls, modelled by Effie's sisters Alice (holding the basket) and Sophie, with Matilda and Isabella from *The Blind Girl*, piling leaves to be burned in a field. The redhead Matilda Proudfoot leans on either a broom or a rake, while young Isabella, dressed in purple, holds the apple. According to Millais, Rossetti was '... aghast with admiration, saying he would rather have the Autumn Leaves than any picture he ever saw.' *The Times* compared the painting with *The Return of the Dove to the Ark* and noticed a development in the force of the handling. The art world celebrated Millais's technical ability and treatment of colour, led by Ruskin who felt Millais had surpassed Giorgione: 'By much the most poetical work the painter has yet conceived ... the first instance existing of a perfectly painted twilight. It is as easy ... to give obscurity to twilight, but to give the glow within its darkness is another matter.' This twilight tonality can be seen later in *Sir Isumbras*. Millais, having intended to imbue the work with a philosophical meaning, was rather disappointed when the apparent religious symbolism went unnoticed: 'I have always felt insulted when people have regarded the picture as a simple little rustic episode chosen for effect and colour, as I intended the picture to arouse by its solemnity the deepest religious reflection.' The melancholic atmosphere, created by the subtle themes of transience and death, is a precursor to Symbolism, using motifs of dead leaves, smoke and the sunset. The girls' youth and innocence will soon be gone. T. S. R. Boase in the *Athenaeum* felt that *Autumn Leaves* and *The Blind Girl*, exhibited at the same time, '... have a unique place in British art.' Millais may have been inspired by helping sweep up and burn dead leaves at Tennyson's home, Farringford, on a visit in November 1854. Painted in Millais's garden at Annat Lodge, Perth, the horizon in the background, behind which the sun is setting, is a view of the hills looking towards the peak of Ben Vorlich. The spire of St John's Kirk can also be seen. A collector of genre paintings, James Eden, had agreed to buy the painting before its completion but tried to get out of his promise. Millais held him to his word and received £700 for it.

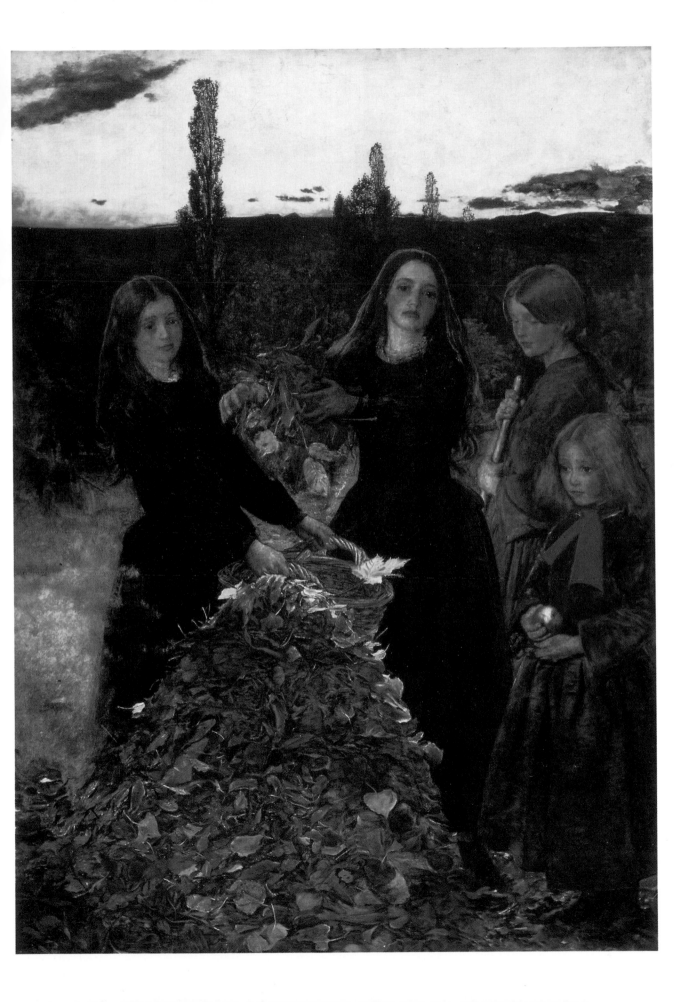

PLATE 19

A DREAM OF THE PAST – SIR ISUMBRAS AT THE FORD

———— 1857 ————

Oil on canvas, 49 × 67 in /124.5 × 170.2 cm
National Museums & Galleries on Merseyside (Lady Lever Art Gallery)

This transitional work, possibly influenced by Albrecht Dürer, was Millais's largest painting to date. Executed near Annat Lodge at the Bridge of Earn, it depicts an aged knight crossing a stream on horseback accompanied by two woodsman's children carrying sticks. The models included Millais's son Everett and a Colonel Campbell for the knight. The evocative, brooding natural setting contains an almost Impressionist treatment of water. The exhibition catalogue entry included lines reputedly from *The Metrical Romance of Sir Ysumbras*. Indeed there was a metrical romance of this name, but it did not feature these lines. They were written specifically for the painting by Tom Taylor, a friend of Millais and later the editor of the humorous weekly *Punch*. Naïvely, Millais anticipated a positive review from *The Times*, which dedicated nearly an entire column to the artist, but the response was not as he expected: 'Much of the picture is carelessly painted, while the composition invites criticism, so daringly does it depart from all received notions of agreeableness and grace.' The tenor of this passage was similar to the criticism vented by most journals. Ruskin, who appreciated the noble subject-matter while suggesting that at its very deepest level the painting could personify the 'Christian Angel of Death', found nothing else to praise in the picture: 'The change in manner, from the years of *Ophelia* and *Mariana* to 1857 is not merely Fall – it is a Catastrophe; not merely a loss of power, but a reversal of principle.' Having been executed directly from nature, close to Pre-Raphaelite principles and much admired by Hunt, he predicted the painting would not be well received. The proud artist blamed disparaging reviews on art world jealousy and animosity, but was reassured by his public popularity. Critically, the painting fared better retrospectively, the landscape being particularly praised. The infamous painting inspired several jokes and caricatures, the most famous by a then unknown illustrator from Norwich, Frederick Sandys, who later became a friend of Rossetti. Prior to the opening of the exhibition, Millais had hastily refused an offer of £800 from Gambart and consequently suffered the humiliation of having to transport the unsold painting from Burlington House. It was eventually bought by the novelist Charles Reade for less than half the amount offered by Gambart.

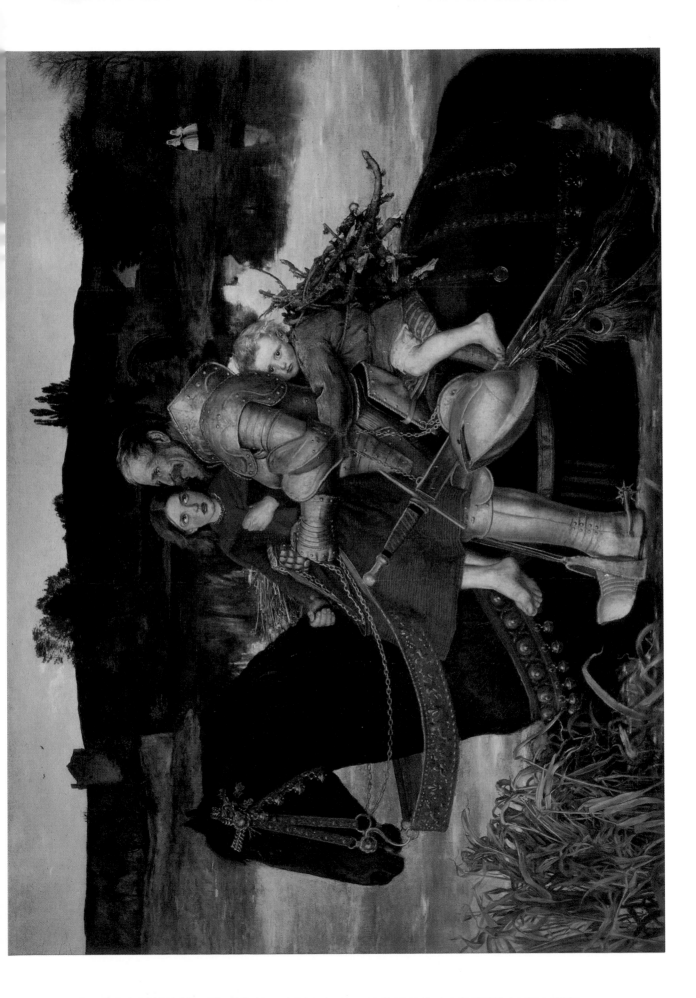

APPLE BLOSSOMS
———— 1856–59 ————
Oil on canvas, 43 ½ × 68 in / 110.5 × 172.7 cm
National Museums & Galleries on Merseyside (Lady Lever Art Gallery)

In late April 1856 Millais wrote to Effie saying he wanted to paint apple blossoms. This very large canvas was begun at Annat Lodge, Perth, in the autumn of 1856 and took nearly four years to complete. Originally planned as a woman sitting under a tree watched by a knight in the background, it was to have been entitled *Faint Heart Never Won Fair Ladye*. The project was abandoned in the spring of 1857 as a new tenant prohibited the artist from painting in the grounds as it would disturb her friends' walks. He then painted trees from neighbouring orchards near Annat Lodge and Bowerswell. The frieze-like picnic scene that replaced the earlier medieval subject was taken from an earlier sketch. *Apple Blossoms*, or *Spring*, as it was originally titled, has no symbolic content and Hunt thought it a fine example of its genre. But the eight girls picnicking in an orchard of apple trees in full blossom were considered ugly and vulgar by the critics. The reviewer of the new periodical *Bentley's Quarterly* described them as '... clothed skeletons, every one of them ugly and ungraceful, with hard features, strained skins, and in broad day with cheeks and lips painted as if for the footlights.' The models included a celebrated beauty named Georgiana Moncrieff, later Lady Dudley, for the kneeling central figure. On her left is Sophie Gray. Alice Gray is shown twice, resting on her elbow and lying on her back on the right. This pose was later used for an etching entitled *A Day in the Country*. The second figure from the right is Helen Moncrieff, later Lady Forbes. The girl in the red cloak is probably Agnes Stewart, described by the artist as 'that little humbug', and the girl second from left was apparently Henrietta Riley. The artist wrote to Hunt accusing Arthur Hughes of stealing his idea of painting an orchard in bloom in his *The King's Orchard*. Effie enthused, 'When the picture of *Spring Flowers* was on the easel out of doors, and in broad sunlight, the bees used often to settle on the bunches of blossom, thinking them real flowers from which they might make their honey.' *Apple Blossoms* was criticized by reviewers for a decline in the quality of Millais's work, particularly the landscape which shows a marked move away from Pre-Raphaelite attention to detail. Millais had trouble selling the painting. It remained unsold at the end of the Royal Academy exhibition and then at the Liverpool Academy in 1859. Gambart bought it in early May 1860 and had to auction it at Christie's a year later. The first collector to purchase the painting was Jacob Burnett of Newcastle in 1861.

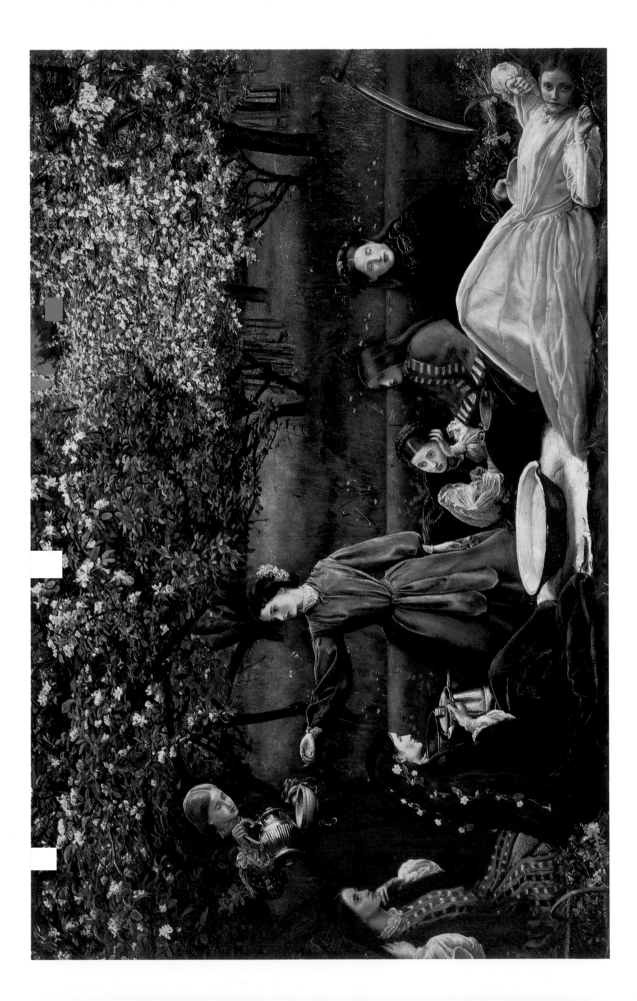

THE VALE OF REST
—— 1858 ——
Oil on canvas, 40 ¹/₂ × 68 in / 102.9 × 172.7 cm
Tate Gallery, London

The title was from a Felix Mendelssohn song which contains the line
'the vale of rest where the weary find repose', which Millais had
heard his brother singing and felt was appropriate for his painting. It
is a milestone piece in the development of his career, with
Pre-Raphaelite attention to detail given what his son described as a
'greater breadth of treatment'. The painting is another with a death
theme, set at twilight in a convent graveyard. One nun digs a grave
while another sits looking at the sky in contemplation, having noticed
a coffin-shaped cloud – a warning of death according to an old
Scottish superstition – and with a skull hanging from her rosary. Effie
described the origins of the painting: 'It had long been Millais's
intention to paint a picture with nuns in it ... we imagined to
ourselves the beauty of the picturesque features of the Roman
Catholic religion, and transported ourselves back to the times before
the Reformation had torn down, with bigoted zeal, all that was beau-
tiful from antiquity, or sacred from the piety and remorse of the
founders of old ecclesiastical buildings in this country.' Much of the
painting was executed in the open air outside their home at
Bowerswell during intense cold as winter set in. The graveyard
section was painted later at Kinnoull Church in Perth.
Retrospectively described by Millais as his favourite painting, *The Vale
of Rest* received mixed reviews. Some felt that the narrative was
unremittingly morbid and inappropriate. Ruskin, however, argued
that had the nuns been beautified, the picture would have lapsed into
sentimentality and lost its realistic power. In spring 1859, Millais
offered the painting to Thomas Combe for 1,000 guineas, but Combe
decided to buy Hunt's *Finding of Christ*, then unfinished, and could
not afford both. Millais felt that his painting was far superior but did
not speak publicly on the matter, not wanting to be accused of envy.
This had been called Millais's last truly Pre-Raphaelite painting. It
was sold to a Mr White, a dealer on behalf of Windus for £700. This
sale helped the artist's two other paintings of this year to sell and
boosted his confidence. Indeed, he received about £1,200 worth of
commissions for new work on the strength of the picture. The face
of the nun on the right was retouched after the exhibition making it
slightly more appealing, using a Mrs Paton as the model, and then
again in 1862 from the head of a Miss Lake.

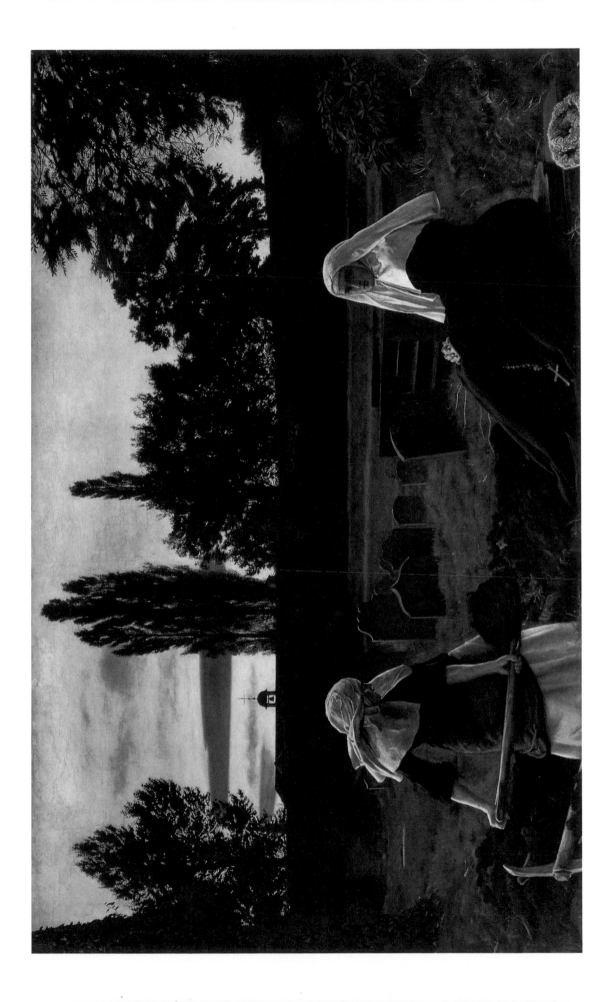

THE BLACK BRUNSWICKER
──────── 1859–60 ────────

Oil on canvas, 39 × 26 in / 99.1 × 66.0 cm
National Museums & Galleries on Merseyside (Lady Lever Art Gallery)

The Black Brunswicker depicts a young officer parting from his English fiancée, modelled separately, she by Charles Dickens's daughter Kate (Millais was on good terms with the Dickens family, despite Dickens's savage attack on *Christ in the House of His Parents*), and he by a private in the First Life Guards who died of consumption a year later, on the eve of Waterloo. Millais needed money and his dealer suggested executing a piece similar to *The Huguenot*. The painting is set in the Napoleonic era in Brussels on the night of the Duchess of Richmond's ball. The officer was from the Prussian cavalry regiment that wore black uniforms with skulls and cross-bones. His lover tries to prevent him leaving by holding the door shut, given moral support by her dog. Behind the couple is an equestrian portrait of Napoleon by David. It is more melodramatic and sentimental than *The Huguenot*, but was popular and emotive for its contemporary audience who would have been aware that nearly the whole regiment was killed in the battle after displaying great valour. Millais was helped by William Russell, a contemporary pioneering war journalist, who gave advice on military matters. This painting was intended as a pendant to the 1852 painting, although it is not of such a high standard. There is some precise detail, for example the creased wallpaper raising from the wall, the sheen and drapery of her satin dress and the hero's uniform copied from a real Prussian one. The treatment of the dog was favourably compared to the work of the great animal painter Edwin Landseer. The artist had trouble with the depiction of Miss Dickens's face. It was restarted when the model noted some exaggeration, after her chaperone refused to make a judgement. This was Millais's only Royal Academy entry in 1860 and he was optimistic about its reception: 'I have it all in my mind's eye, and feel confident that it will be a prodigious success.' The painting was still unsold in early June, though Millais had anticipated selling it for 2,000 guineas. However shortly after this Gambart paid a more realistic price of 1,000 guineas and sold it on to Thomas Plint. An engraving of the picture was made in 1864 by T. L. Atkinson.

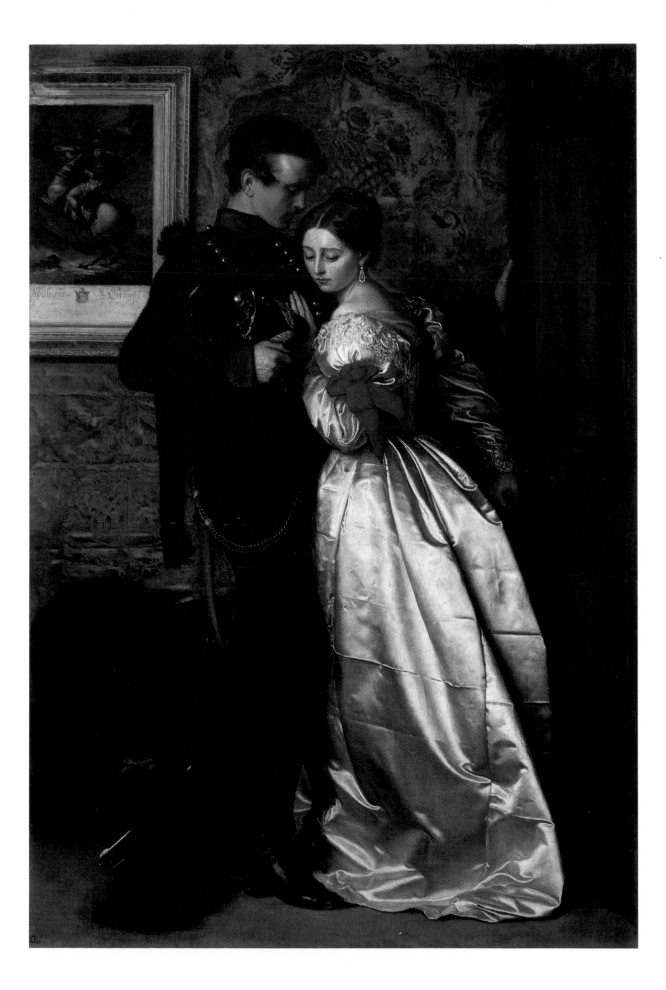

PLATE 23

TRUST ME

———— 1862 ————

Oil on canvas, 44 × 30½ in / 111.8 × 77.5 cm
The Forbes Magazine Collection, New York

Genre paintings containing hints of clandestine love affairs were extremely popular among the Victorian public, and may be seen as the visual equivalents of the novels of the period. *Trust Me*, in particular, bears close affinities to the illustrations to the novels of Anthony Trollope that Millais had begun in 1860 with six drawings for *Framley Parsonage*. In 1862 he was at work on illustrations for *The Small House at Allington*. The action of the novels is set in the fictitious county of Barset, and here Millais has indicated that the location is rural, rather than urban, by showing the man dressed for the hunt. The *Art Journal* was convinced that the painting was designed to inform us that '... a young lady has received a letter, which her father desires to see.' It was impressed too by Millais's ability to convey the story with clarity, noting, 'Nothing can surpass the clearness of the narrative; this, indeed, is what Mr Millais always strives for, and wherein he most frequently succeeds.' However, the subject of the painting remains enigmatic: is the man the woman's father or husband? is her stance demure or defiant? is the letter she clutches from a lover? and, finally, who is declaring (or asking) the 'trust me' of the title?

PLATE 24

THE EVE OF ST AGNES
———————— 1862–63 ————————

Oil on canvas, 46½ × 61 in / 118.1 × 154.9 cm
Her Majesty Queen Elizabeth The Queen Mother

Here Madeline disrobes in the moonlight as her voyeuristic lover
Porphyro watches secretly from a closet. This scene was inspired by
the Keats poem of the same name which had inspired Hunt's final
Pre-Raphaelite painting, specifically the stanza that contains the lines:

> Anon his heart revives: her vespers done,
> Of all its wreathèd pearls her hair she frees;
> Unclasps her warmèd jewels one by one;
> Loosens her fragrant bodice; by degrees
> Her rich attire creeps rustling to her knees.

However, Millais's version is far removed from Pre-Raphaelite prin-
ciples as it is so historically inaccurate as to be anachronistic. The
girl, who looks contemporary, stands in a Jacobean rather than a
fourteenth-century room. F. G. Stephens wrote in the *Athenaeum*,
'There is a charm of execution ... which carries thought away from
its absurdity. The anachronism is so thorough ... We cannot fail to
see that the idea is as much the artist's own as that of Keats.'
Millais's setting was the King's Bedroom in England's largest private
house, Knole in Kent, featuring the bed of King James I with its
opulent bed linen and original silver fittings. He painted late in the
evening in full moonlight to obtain realistic atmospheric effects,
enduring freezing conditions that numbed his fingers. The picture was
executed at great speed in just five-and-a-half days — three and a half
at Knole and two at home, using a bull's-eye lantern to create a
similar lighting effect. Despite the adverse conditions under which it
was executed, *The Eve of St Agnes* was considered to be one of Millais's
greatest paintings, and one which shows a complete reversal of previ-
ous principles. At Knole, Effie sat for Madeline, whose figure was
finished from the professional model Miss Ford. Unfortunately, when
the picture was exhibited, the audience found the Madeline unattrac-
tive and rigid, Tom Taylor unkindly describing her as 'scraggy' and
Sir Frances Grant complaining, 'I cannot bear that woman with the
gridiron' (a reference to the pattern on the floor). The painting was
bought for £800 by Gambart who sold it on to Charles Lucas by
1865. It was then acquired by the artist Val Prinsep who was very
enthusiastic about his purchase, describing it as '... essentially a
painter's picture'.

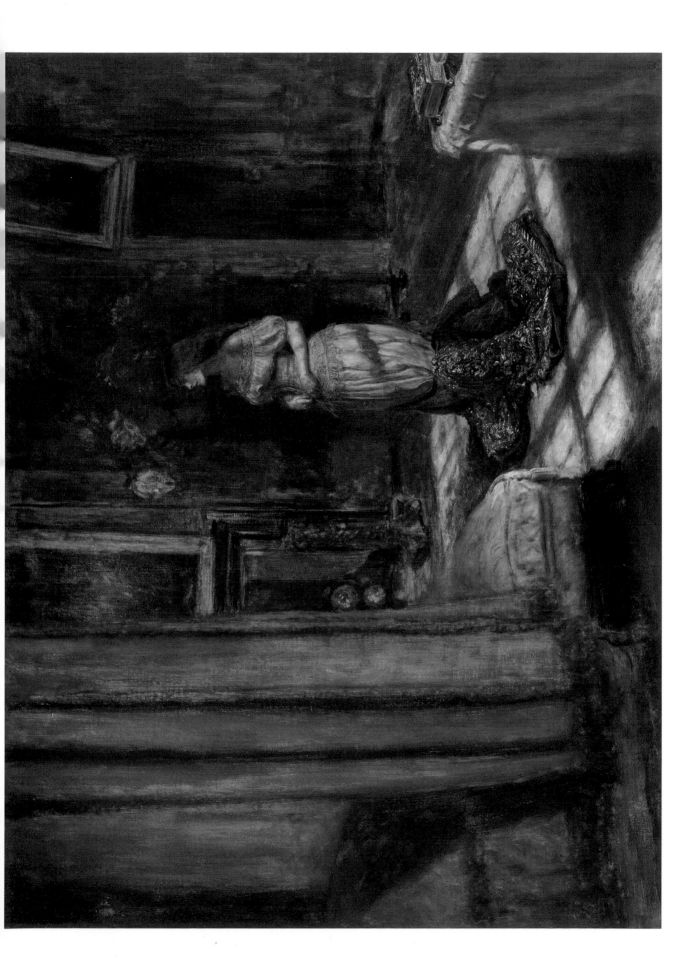

PLATE 25

MY FIRST SERMON
————— 1863 —————

Oil on canvas, 36 ½ × 28 ½ in / 92.7 × 72.4 cm
Guildhall Art Gallery, Corporation of London

My First Sermon was Millais's first sentimental depiction of a child, and marks the beginning of a long and profitable series of similarly attractive works featuring young girls. It was modelled by his five-year-old daughter Effie, the first time she had sat for a painting. She later became Mrs James, the mother of the young boy subject of his celebrated *Bubbles*. When the picture was exhibited at the Royal Academy, in a speech at the Academy banquet the Archbishop of Canterbury used the picture to exemplify the 'piety of childhood'. The high-backed pew (no longer extant) was painted in a church at Kingston-on-Thames where the artist's parents lived. The popularity of the picture led to a sequel being painted in the following year. Millais had already painted a highly finished oil copy in August 1863, completing it in just two days and selling it for £180, commenting, 'I never did anything in my life so well or so quickly.' A watercolour of the subject was bought by Charles Langton. The original work was in the collection of Charles Gassiot by 1886, and was bequeathed to the Guildhall in 1902, along with its sequel.

MY SECOND SERMON
————— 1864 —————

Oil on canvas, 36 × 28 in / 91.4 × 71.1 cm
Guildhall Art Gallery, Corporation of London

Begun in January 1864, this was painted to capitalize on the success of *My First Sermon*. It was rejected by the Royal Academy Committee, however, on the grounds of its plagiarism of the earlier painting. This painting was similarly mentioned in a speech by the Archbishop of Canterbury, 'I see a little lady here ... who, though unconscious whom she has been addressing ... has in truth, by the eloquence of her silent slumber, given us a warning of the evil of lengthy sermons and drowsy discourses. Sorry indeed should I be to disturb that sweet and peaceful slumber, but I beg that when she does awake she may be informed who they are who have pointed the moral of her story.' As with its companion, Charles Langton owned a watercolour version. The original was owned by Charles Gassiot who bequeathed it to the Guildhall with *My First Sermon*.

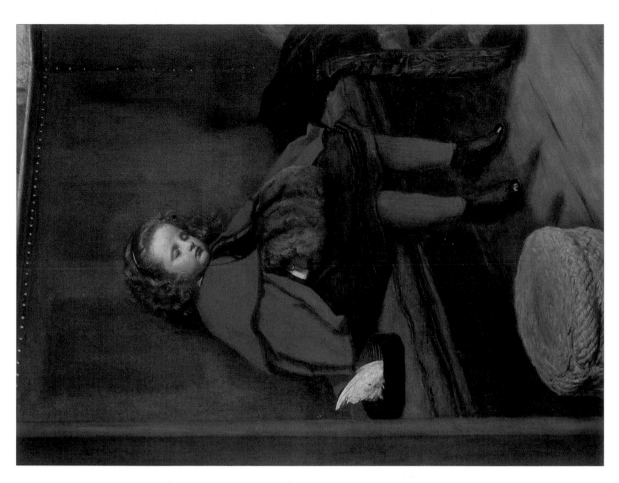

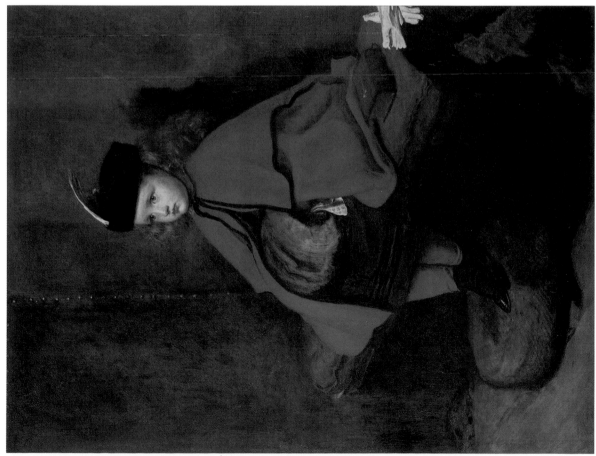

LEISURE HOURS
———— 1864 ————

Oil on canvas, 33 × 46 in / 83.8 × 116.8 cm
Detroit Institute of Arts (Founders Society Purchase, Robert H. Tannahill
Foundation Fund)

This is a double portrait of Anne (on the right) and Marion (on the left), the daughters of Sir John Pender of Middleton Hall, Linlithgow, and his second wife Emma, *née* Denison. Pender was the Liberal Member of Parliament for Totnes in Devon, as well as a businessman involved in both textiles and telegraphy. Anne (1852–1902) never married; Marion (1856–1955) married Sir George William Des Voeux in 1875. The rich red and green, also seen in his anecdotal sermon paintings, were typical of Millais's work at this time. The screen recalls hangings in *Mariana* but has a very different ambience, this being wholly populist and aimed at the print market. The tense, eerie mood is reminiscent of *Autumn Leaves*. The goldfish bowl is symbolic of the artifice in the lives of upper-middle-class girls like the Pender sisters. Sir John Pender collected modern British art, having recently bought Millais's *The Proscribed Royalist* and *The Parable of the Tares*. Until recently the painting was still owned by the Pender family by descent.

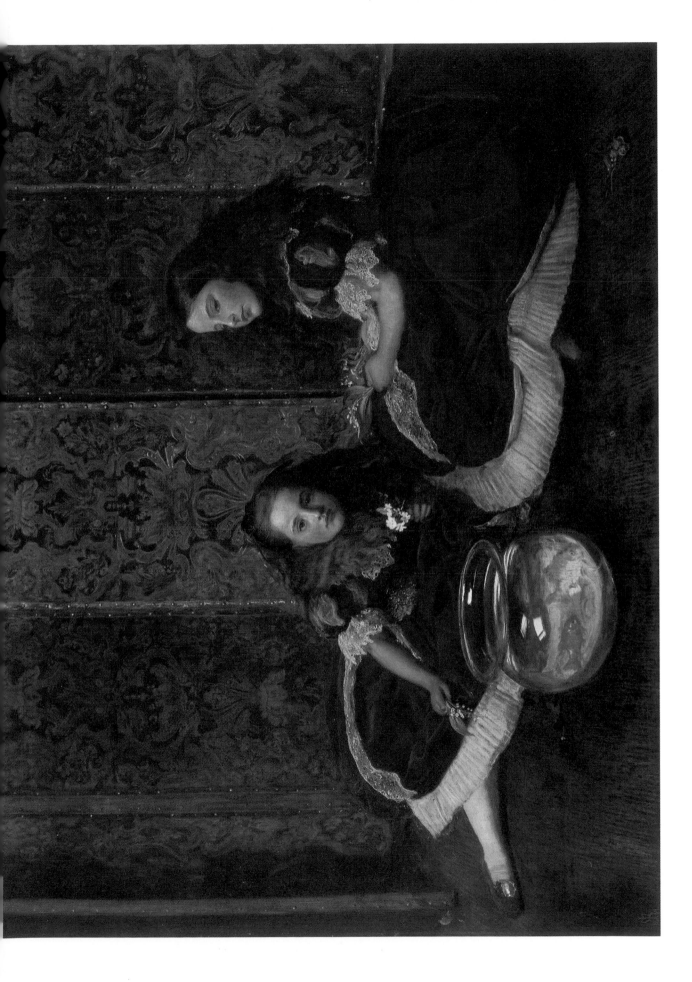

The Boyhood of Raleigh

—— 1870 ——

Oil on canvas, 47½ × 56 in / 120.7 × 142.2 cm

Tate Gallery, London

The subject was suggested to the artist on reading the historian James Anthony Froude's 'England's Forgotten Worthies' in the *Westminster Review* of 1852. The young Raleigh and his brother listen keenly to the tales of an old Genoese sailor's adventures on the Spanish main. The artist's sons Everett and George sat for the two boys and a professional model took the part of the elderly sailor. The seascape was painted on the Devon coast close to Exeter, Raleigh's home town, on the land of Lady Rolles. F. G. Stephens wrote, 'This work glows in the warm light of a Devonshire Sun ... The young Walter sits up on the pavement ... and with fixed, dreaming eyes, seems to see El Dorado, the islands of the east and west, the palms and temples of the south ... ships, gold, the hated Spaniards, and ... the "fountain of youth" were before his fancy.' The toy boat in the bottom left corner is prophetic of the young Walter's maritime adventures as an adult.

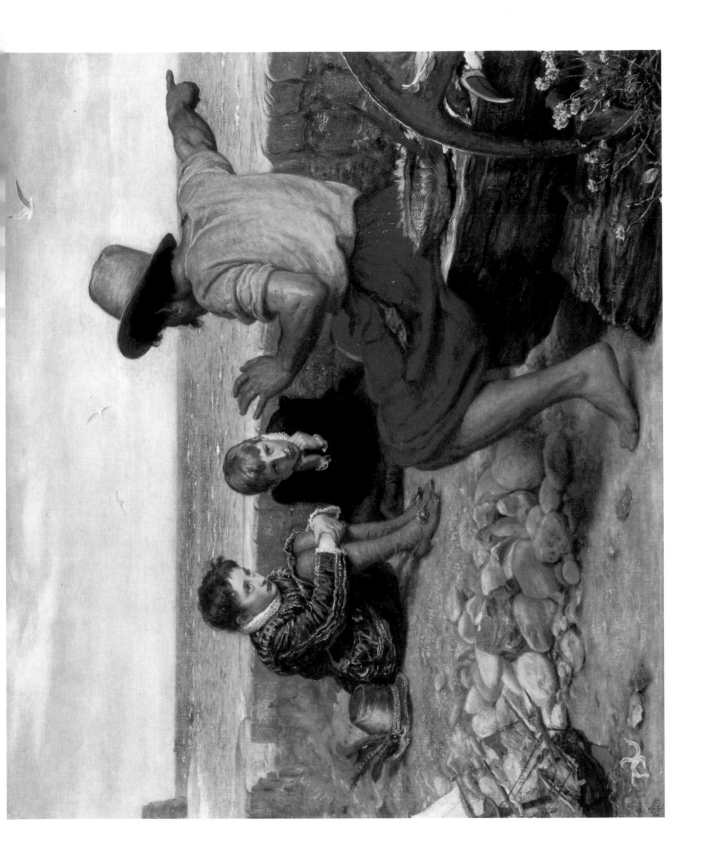

PLATE 28

CHILL OCTOBER
—— 1870 ——

Oil on canvas, 55½ x 73½ in / 141.0 x 186.7 cm
Collection of Sir Andrew Lloyd Webber

This was Millais's first autumnal Scottish landscape. The wild and isolated terrain is a backwater of the River Tay known locally as 'Seggy Den', five miles from Perth, just below Kinfauns. Millais wrote, 'The scene, simple as it is, had impressed me for years before I painted it. I made no sketch for it, but painted every touch from Nature, on the canvas itself, under irritating trials of wind and rain.' The amateur critic, Lord Justice James, recognized Millais's evocation of autumn: 'Every true painter is a poet. A good landscape is especially a descriptive poem, and in this landscape the artist has shown us how well he has seen, how thoroughly he has felt, and how truly he has followed nature.' Probably his best landscape, *Chill October* was one of Millais's most popular paintings, though not unique: during the 1870s the artist produced a pure landscape almost annually. There are no sophisticated allusions to atmosphere, but there is a great degree of botanical accuracy in the treatment of the reeds, rushes, willows, the stream, the sky and the background hills, Millais altering nothing from the scene in front of him. Marion H. Spielmann remarked, 'Millais could paint the time of day; he could moreover draw a tree, as few of his contemporaries could do; and sky and grass and dew-drenched heather, luminous screen of cloud and tangled undergrowth – he painted them all, not only with love, but with an enthusiasm which he had the happy faculty of imparting to the spectator.' A bemused local railway porter helped the artist carry his canvas and easel. On reading that the painting had been sold to Samuel Mendel for £1,000 in 1871, he remarked that he would not have given half-a-crown for it. In 1875 it was bought at Christie's by Agnew for £3,253, and in 1883 was made the subject of an engraving by Brunet Debaires.

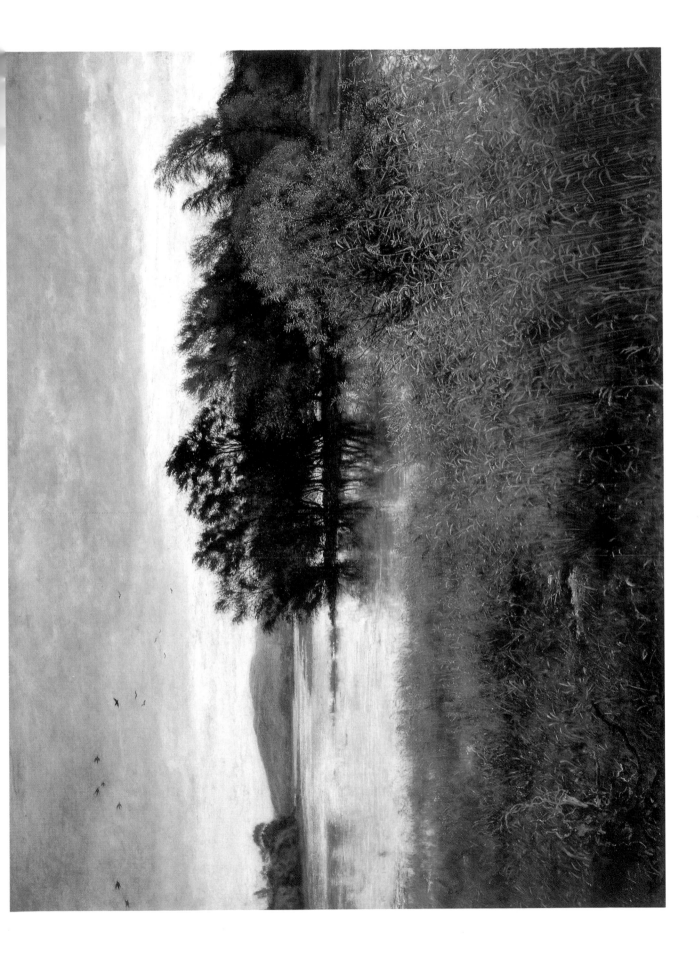

PLATE 29

THE KNIGHT ERRANT
— 1870 —
Oil on canvas, 72½ × 53¼ in / 184.2 × 136.3 cm
Tate Gallery, London

The 1886 Grosvenor Gallery exhibition of Millais's works describes the action depicted in this unusual subject: 'Attacked by robbers! Such has been the fate of the damsel in the picture. Not content with stealing all her valuables, the thieves have tied her naked to a tree, leaving her clothes in a heap on the ground. A knight wandering about, ever ready to avenge misfortune, sees her plight, and is on the point of releasing her. The pale crescent of the new moon light the picture, and we see the retreating figures of her assailants.' *The Knight Errant* was one of Millais's very rare nude scenes. According to his son John Guilles Millais, 'Mrs Grundy was shocked, or pretended to be so, and in consequence it remained long on the artist's hands, no one daring to buy it. At last (in 1874) a dealer purchased it, and (with this "hall mark") it at once gained the favour of the public.' Painted from professional models, with the background painted at Wortley Chase, Millais originally depicted the woman facing toward the spectator, but was dissatisfied with the effect and even threatened to destroy it. Having removed that portion of the canvas, which he reworked as *The Martyr of the Solway*, however, he then repainted the head, turning it away as if in shame, with a result he found acceptable.

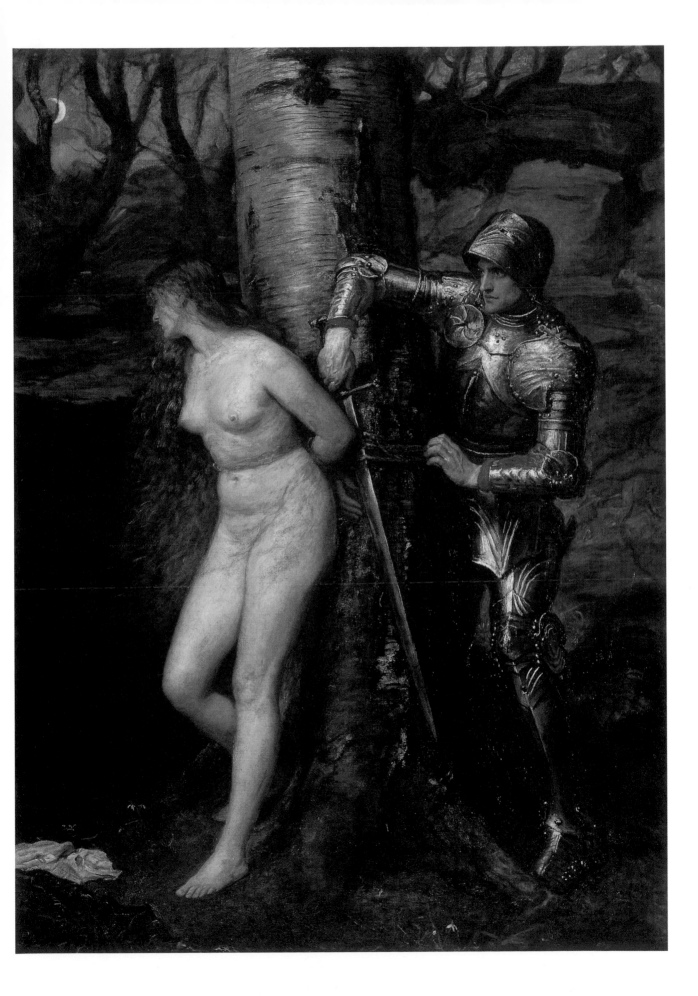

THE MARTYR OF THE SOLWAY
─────── 1871 ───────

Oil on canvas, 27 ¾ × 22 ¼ in / 60.3 × 56.5 cm
National Museums & Galleries on Merseyside (Walker Art Gallery)

This painting depicts Margaret Wilson of Wigtownshire (1667–85) who was a Covenanter. Refusing to acknowledge the Episcopacy, she was sentenced to execution by drowning in the Solway. Millais's illustration of this subject, showing Margaret Wilson in a full-length pose, was published in the journal *Once A Week* in July 1862. The head and bust of the figure in this painting originally belonged to the woman in Millais's *The Knight Errant* of 1870, which he cut out and replaced with a new piece of canvas, painting the woman facing away. The original piece of canvas was then pasted on to a new canvas and her nude figure clothed to create this work.

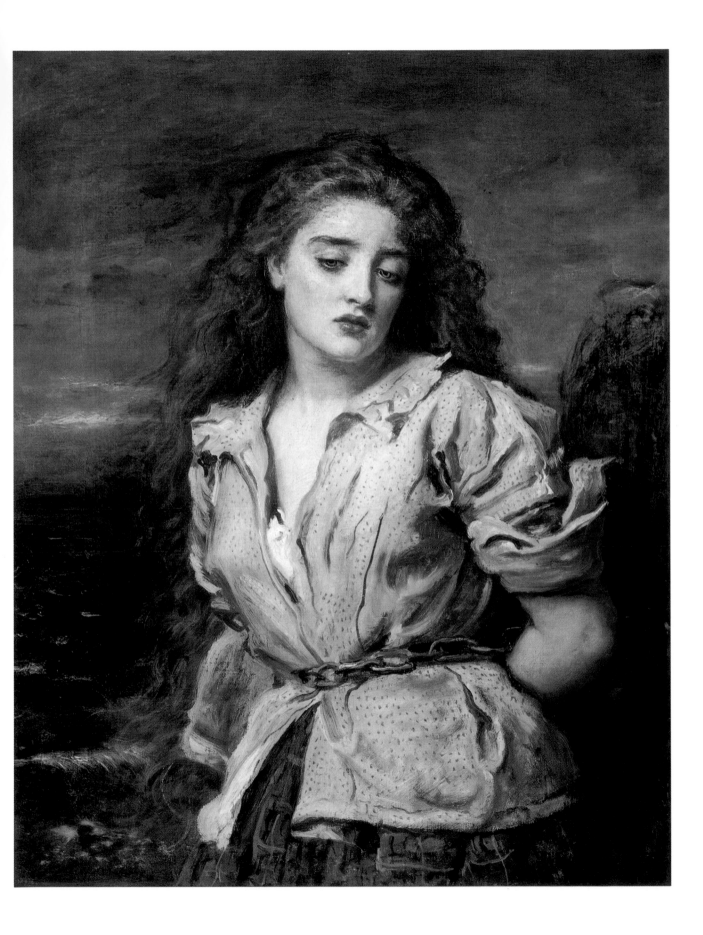

PLATE 31

HEARTS ARE TRUMPS
—— 1872 ——

Oil on canvas, 65¼ × 86½ in / 165.7 × 219.7 cm
Tate Gallery, London

This scene of contemporary life depicts three beautiful and glamorously attired young women sitting around a card table. The spectator participates in the game of Dummy Whist, being shown the good hand of the player on the right. This compositional device was common in nineteenth-century domestic realism. The models were the daughters of the inventor and industrialist Sir William Armstrong, Elizabeth, Diana and Mary, later Mrs Tennant-Dunlop, Mrs Secker and Mrs Blennerhasset. Inspired by Millais's *Sisters*, Armstrong, co-founder of the armaments company Vickers Armstrong, requested a portrait of his daughters, price being no object. On 5 August 1871 Millais wrote to Effie, 'They know the price and are prepared to give anything I ask.' In 1875 it was bought by Armstrong for 200 guineas. Millais himself designed the opulent dresses and executed them with a triumph of technique in a masterpiece of fashion portraiture, its delicate handling of textures on a par with Leighton. The arrangement of the sitters is reminiscent of Sir Joshua Reynold's *Three Ladies Waldegrave*, also a triple portrait, which hung at Strawberry Hill, then the home of the Countess of Waldegrave. The background shows the influence of oriental arts, *Japonisme* being a fashionable style in 1870s Britain. *Hearts Are Trumps* received enthusiastic and positive reviews when exhibited at the Royal Academy. The Athenaeum critic wrote, 'Mr Millais will hold a position second to none this year, principally through his superb portraits, conspicuous among which is the picture styled *Hearts Are Trumps* … the painting is as brilliant, lucid and formidable as a Velasquez, and as broad as a Reynolds. It contains what, on the whole, are the best portraits Mr Millais has produced.' In 1878 the painting was shown at the Exposition Universal in Paris. It inspired John Singer Sargent's portrait of the three daughters of Colonel Thomas Vickers.

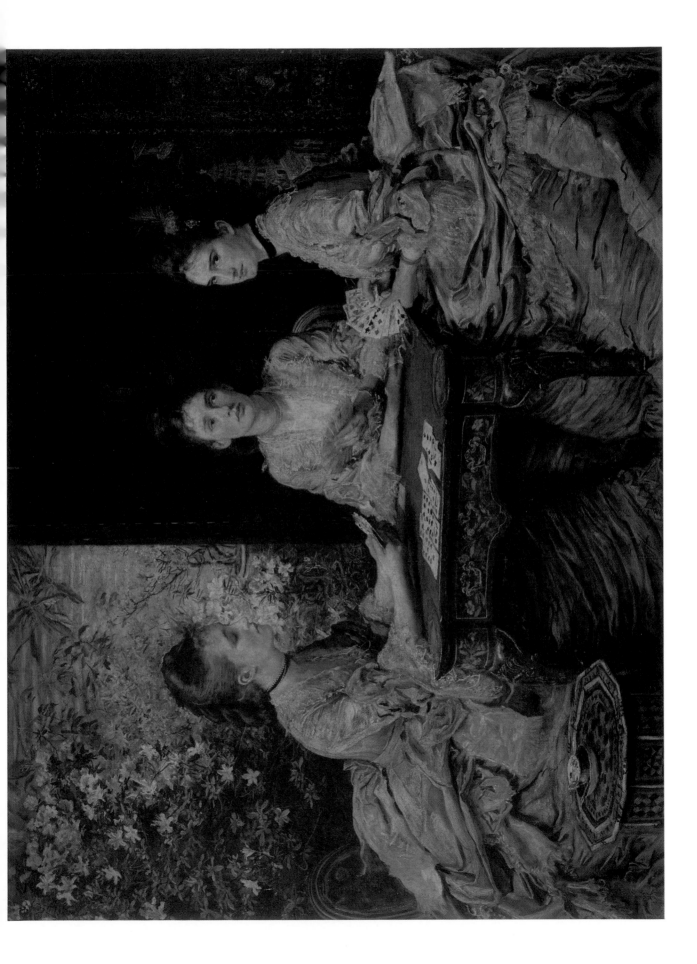

The North-West Passage
------- 1874 -------

Oil on canvas, 69 1/2 × 87 1/2 in / 176.5 × 222.3 cm
Tate Gallery, London

This unusually serious painting for Millais was imbued with sincere middle-class patriotism. Extremely popular, it was always surrounded by a crowd at the Royal Academy. Millais received a letter from Sir George Narks, who commanded the expedition to the North Pole in 1879, praising the painting's effect on national morale. The work was subtitled 'It might be done and England should do it'. In this period it was hoped that a safe shipping passage from the Far East via the north of Canada would be established. An aged mariner sits in a room of nautical paraphernalia, with an open map and a glass of brandy. His daughter, modelled by the woman who also appeared in *Stitch! Stitch! Stitch!* of 1876, reads to him from an account of one of his expeditions. He remembers his own past experiences at sea, his weather-beaten face clearly moved with nostalgia. The old man was modelled by Captain Edward John Trelawny, an eccentric friend of Byron and Shelley, about both of whom he reminisced in his autobiography *Adventures of a Younger Son*. Among his many adventures he had been captured by Greek pirates who took him ashore; after marrying the daughter of the chief, he spent his honeymoon in a cave. At first this authentic ancient mariner refused to sit for Millais because he despised contemporary culture. Even after Trelawny introduced himself to Millais at the funeral of a mutual friend, John Leech, the artist was afraid to ask him again. Effie decided to confront this awkward old man and they eventually agreed upon a bargain. Trelawny would sit for six sessions as long as Effie agreed to take six Turkish baths, accompanied by his niece, the elderly sailor having an interest in a company promoting Turkish baths in London. Surprisingly, the old sea dog did not drink alcohol and complained about the proposed tumbler of brandy in the composition. The artist waited for the completion of the six sittings before he painted in the controversial glass. Trelawny was angered when he saw the completed canvas in the Academy, fearing recognition. At one stage of the painting's execution, two children, modelled by the artist's own offspring, were introduced in the right corner looking at a globe. Millais decided that the children ruined the simplicity of the story and the composition. The canvas was then cut and a new section stripped in on which the children were replaced by an old English flag.

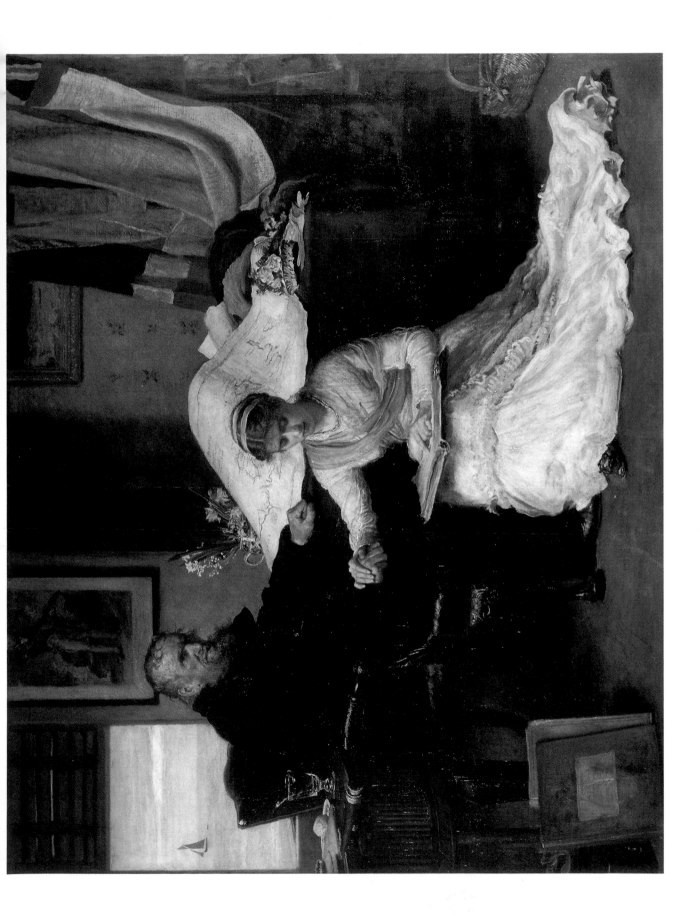

A JERSEY LILLY (LILLIE LANGTRY)
──────── 1878 ────────

Oil on canvas, 43 1/2 × 33 1/2 in / 110.5 × 85.1 cm
Jersey Museum Service

This is a portrait of the famous actress Lillie Langtry (1853–1929) at her most beautiful. Not only was she a close friend of Millais's family, but she also had a shared ancestry with the artist, descending, like Millais, from an old Jersey family. Born Emilie Charlotte Le Breton, she was the daughter of William Le Breton, the Dean of Jersey. In 1874 she married Edward Langtry, the son of a wealthy shipowner, and moved to London where she acquired the nickname 'Jersey Lily'. There she became celebrated as a society beauty and as the mistress of the Prince of Wales, later Edward VII. She entered this role in 1877, when she first posed for Millais in the title role of *Effie Deans*, a painting based on Sir Walter Scott's novel *The Heart of Midlothian* (1818). The following year Millais painted this formal portrait, which was exhibited at the Royal Academy along with his equally famous *The Princes in the Tower*. She became well-known as an actress in Britain and the USA, and died in France, but was buried in the churchyard of St Saviour's in her native Jersey.

PLATE 34

THE PRINCES IN THE TOWER
───── 1878 ─────

Oil on Canvas, 58 × 36 in / 147.3 × 91.4 cm
Royal Holloway and Bedford New College, University of London

This historical painting depicts the sons of King Edward IV who were imprisoned in the Tower of London by Richard Duke of Gloucester, who claimed the throne for himself. One is Edward V, the rightful heir to the throne, then aged thirteen, and his younger brother Richard, the Duke of York, aged ten in 1493, the year of their father's death. In this tense composition, the boys are caught at a moment just prior to their murder. The painting was extremely popular, the mezzotint being widely distributed, but Millais was criticized for the morbid nature of the subject. It was popularly believed that the boys were suffocated in their sleep with pillows, and in 1674 the skeletons of two children were found under the staircase in the White Tower, hence Millais's setting, perhaps also inspired by an 1831 Paul Delaroche painting of the same subject. Millais's son John had sketched in the Bloody Tower, but on finding the staircase too small and the wrong way round, Millais went to sketch there himself. He had already painted a background for this painting at St Mary's Tower at Birnam, but rejected it, although this incomplete canvas provided the background for *The Grey Lady* of 1883. Prince Edward wears the Order of the Garter on the advice of James Robinson Planché, an eminent costume historian and heraldic expert. A year later Millais executed a companion painting, *Princess Elizabeth in Prison at St James's*. It depicts the second daughter of Charles I and Henrietta Maria who spent most of her short life imprisoned in St James's Palace. She is shown writing a letter to Parliament requesting to be reunited with her servants. Princess Elizabeth was moved to Carisbrook Castle on the Isle of Wight, where she died in 1650, aged fifteen. These two paintings are more exceptional than Millais's usual child themes, not only because they depict historical figures (although he had already painted Sir Walter Raleigh as a boy), but because all three children died in captivity. The princes had provided a common subject in British art since the eighteenth century, but were shown at a less tense moment by artists such as Opie and Northcote. *The Times* reviewer wrote, 'The painter has admirably expressed in these young faces the trouble of continued fear bent with the agitation of sudden alarm, and it is greatly to his praise that ... his work should awaken no thought of plagiarism. The execution is consummate, and thoroughly carried through the picture.'

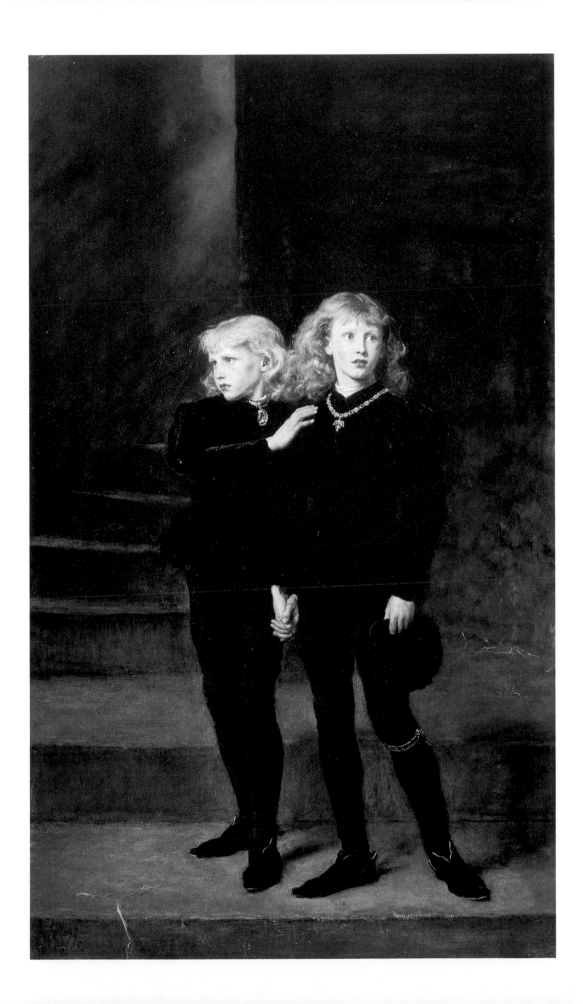

LOUISE JOPLING
—————— 1879 ——————
Oil on canvas, 48 1/2 × 29 1/2 in / 123.2 × 74.9 cm
Private collection

Millais painted numerous portraits of the eminent men and women of the day, among them writers and poets including Carlyle and Tennyson, Prime Ministers Gladstone, Disraeli and the Marquis of Salisbury, and actors and actresses such as Sir Henry Irving and Lillie Langtry. This simple and elegant portrait was, according to his son John Guille Millais, 'One of the finest that ever came from his brush'. Louise Goode (1843–1933) was first married to Frank Romer, the private secretary of Baron Rothschild. While living in Paris, the Baroness encouraged her to take painting lessons. Following the death of Romer, she married Joseph Middleton Jopling, a painter and a close friend of Millais (like Millais, 'Joe' Jopling was a shooting enthusiast, representing England in competitions), and as Louise Jopling achieved celebrity as a portrait painter.

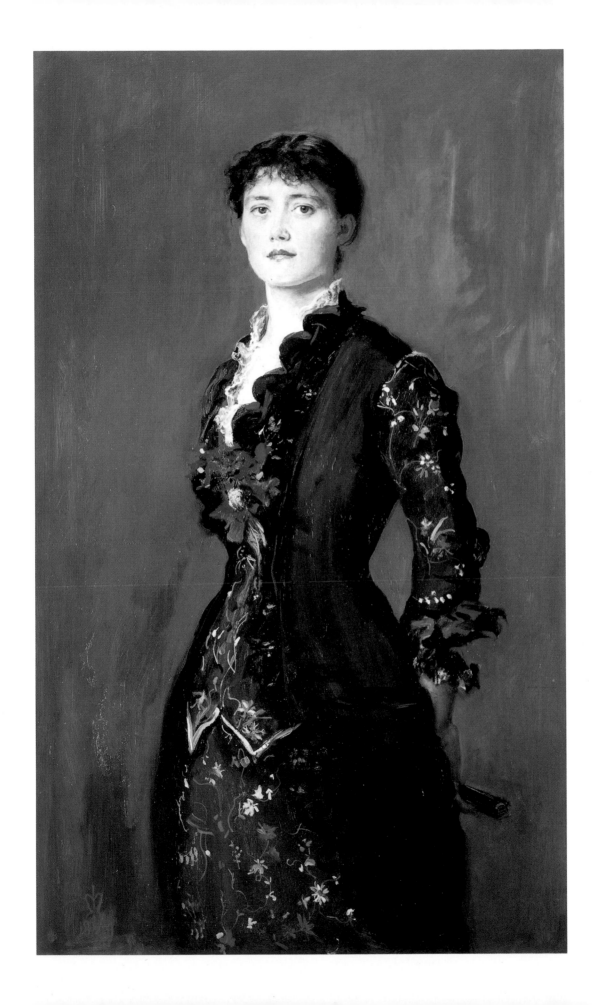

SELF-PORTRAIT
——— 1880 ———

Oil on canvas, 33 ¼ × 25 ½ in / 86.0 × 65.0 cm
Uffizi Gallery, Florence

Along with contemporaries such as Alma-Tadema and Leighton, Millais was invited to paint himself for the Uffizi's collection of artists' self-portraits. Millais executed the painting in just a few days with ease, using the huge mirror from his Palace Gate studio beside his canvas. He explained, 'You see, it is done very quickly, for as I know exactly when to keep still, I'm a pretty good sitter.' Millais depicted himself full of health and vitality. The self-portrait was generally regarded as the best representation of the artist, one contemporary critic describing it as 'Holding its own with singular power among the auto-portraits of the great masters of the world, from the mighty painters of Italy down to the present day.' Unlike more bohemian artists, the conservative Millais dressed in the style of a successful businessman. He had once visited a phrenologist named Donovan, who from Millais's manner deemed him to be uncreative, logical and a shrewd businessman, much to the artist's indignation. The Garrick Club holds a copy of this work. Millais also painted a self-portrait three years later for the collection of artists' self-portraits founded by Alexander McDonald of Aberdeen.

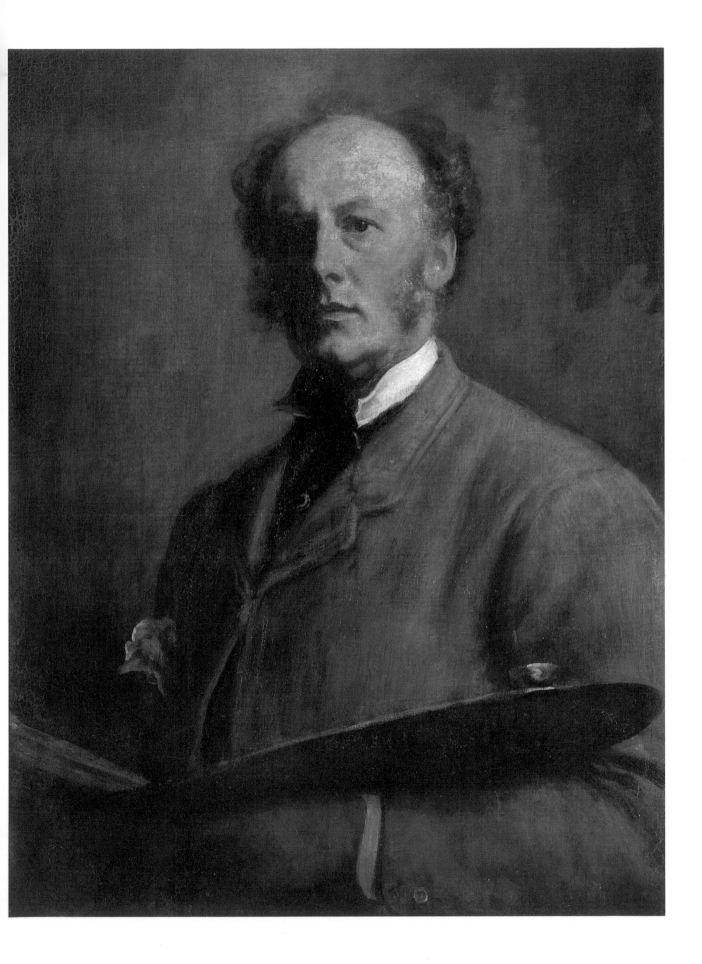

PLATE 37

CALLER HERRIN'

—— 1881 ——

Oil on canvas, 43½ x 31 in / 110.5 x 78.7 cm
Private collection

The 1886 exhibition of Millais's paintings at the Grosvenor Gallery provided a description of this work: 'A beautiful young fisher girl is resting for a moment as she carries home her load of fish. She is gazing over the sea, thinking perhaps of her absent lover. Every detail is carefully rendered; the scales of the herrings on the basket glitter in the bright sunlight.' In his *Art of England* John Ruskin drew special attention to the work: '... a picture which, as a piece of art, I should, myself, put highest of all yet produced by the Pre-Raphaelite school – in that most noble picture, I say, the herrings were painted just as well as the girl, and the master was not the least afraid that, for all he could do to them, you would look at the herrings first.'

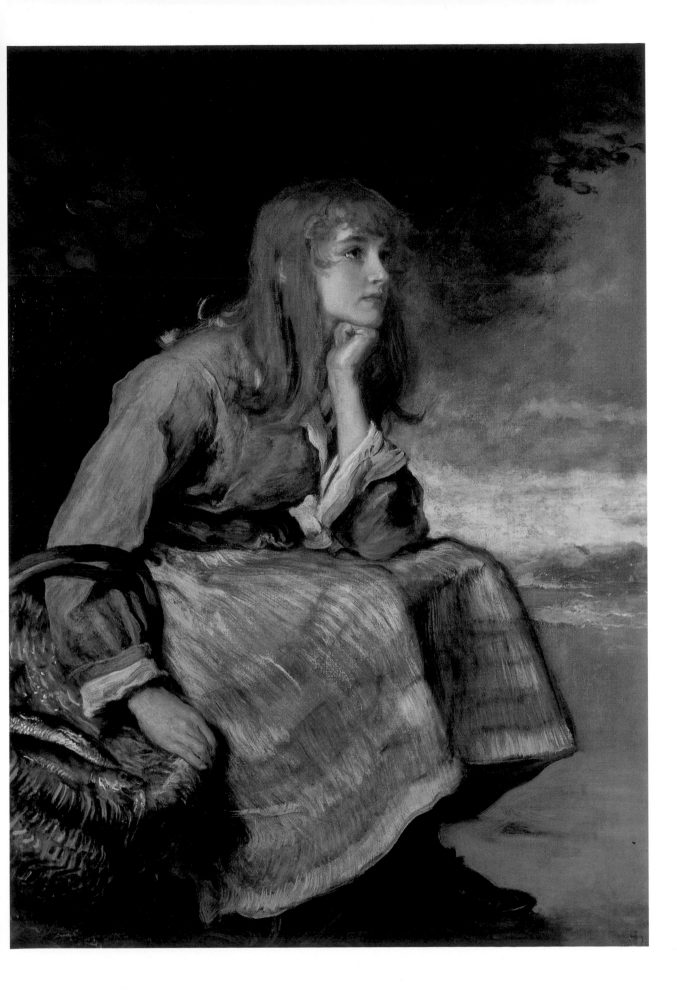

PLATE 38

THE RULING PASSION
(THE ORNITHOLOGIST)
———— 1885 ————

Oil on canvas, 63¼ × 85 in / 160.7 × 215.9 cm
Glasgow Art Gallery and Museum

Millais was inspired to paint this work, which he painted in the year that he became a baronet, after paying a visit to the home of John Gould (1804–81), a distinguished ornithologist, who was noted as a curmudgeonly invalid. He did not begin it until after Gould's death, finishing it in time for the 1885 Royal Academy show. T. Oldham Barlow, an engraver and fellow Royal Academician, sat for the figure of the aged ornithologist, while Millais's own grandchildren, William (the subject of *Bubbles*) and George James, modelled the small children. Ivor Byng, the son of the Reverend Francis Byng, the former chaplain to the House of Commons, sat for the boy in a sailor suit, and a professional model (who appeared later in *The Nest*), as the girl on the left. Millais was delighted with the picture, which was warmly praised by Ruskin, who wrote, 'I have not seen any work of modern Art with more delight than this.' It remained unsold, however, causing Millais to speculate on whether he should '... trouble the critics and public any more with what is called "an important picture".'

BUBBLES
—— 1886 ——

Oil on canvas, 43 × 31 in / 109.2 × 78.7 cm
Elida Gibbs Collection

Originally entitled *A Child's World*, this is a portrait of the artist's grandson William, born in 1881. The son of Effie junior and Major William James, he went on to become Admiral Sir William James. Millais saw his grandson playing with a pipe and soap bubbles and was inspired to paint him, 'bubbles and all', for his own pleasure. The child was happy to sit, anticipating being told fairy stories by his grandfather. The bubbles, described by his son as 'too evanescent for portraiture', proved too challenging and were painted from glass spheres manufactured for the purpose. Beatrix Potter noted in her journal of 15 November 1885 that Millais had visited her home to ask her father to photograph Willie, so that he could compare the photograph to life. The painting was purchased, with copyright, by Sir William Ingram for the *Illustrated London News* for its Christmas 1887 issue presentation plate, as they had done with *Cherry Ripe* in 1879. However, before publication the copyright was sold to Messrs A. and F. Pears, who used it as an advertisement for their transparent soap, adding the soap to the coloured reproduction. Millais, accused of commercialism, was furious and protested – though in vain as he knew they had every right to do as they wished. He was criticized in 1895 by the novelist Marie Corelli who has a character in her novel *The Sorrows of Satan* remark, 'I am one of those who think the fame of Millais as an artist was marred when he degraded himself to the level of painting the little green boy blowing bubbles of Pears' soap.' She later apologized to the artist by letter when he corresponded about the facts of the sale, observing, 'I have seen and loved the original picture – the most exquisite and dainty child ever dreamed of, with the air of a baby poet as well as of a small angel – and I look upon all Pears posters as gross libels, both of your work and you … I hope you will forgive me my excessive zeal; for now that I know you had nothing to do in the "soap business", I will transfer my wrath to the dealer, and pray you to accept my frank apologies.' The novelist agreed to alter the dialogue in the next edition of her novel.

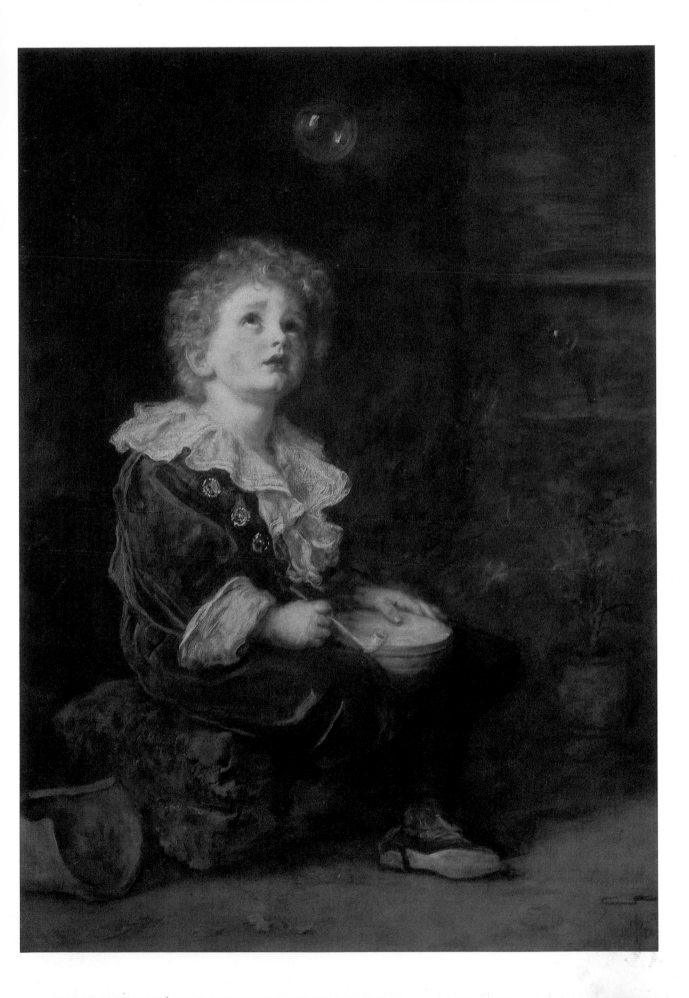

MERCY – ST BARTHOLOMEW'S DAY, 1572

——— 1886 ———

Oil on canvas, 72 1/2 × 51 1/2 in / 181.6 × 130.8 cm
Tate Gallery, London

Millais had a decade of productive work ahead of him when he executed this painting. He occupied his remaining years with landscapes, portraits of wealthy clients such as Vanderbilts and Rothschilds, and the occasional genre picture, but with few exceptions it is clear that the days of his great masterpieces were drawing to a close. *Mercy – St Bartholomew's Day, 1572* was in effect a reprise of *The Huguenot* of thirty-five years earlier in a depiction of an imaginary incident during the St Bartholomew's Day Massacre. The models were the Marchioness Granby as the nun, Geoffroy Millais as the cavalier and the Reverend Richard Lear as the priest. It was reportedly one of the most troublesome pictures Millais had attempted. He wrote dejectedly to the painter Briton Riviere on 11 July 1886, 'I have done the picture. That is, I have only, I hope, small things to complete it. I am sometimes happy over it, but oftener wretched ... People pass it, and go to a little child-picture, and cry "How sweet!" Always the way with any attempt at something serious. Bring Calderon [the painter Philip Hermogenes Calderon] with you if he cares to see an old hand's last performance. I feel a very poor old thing.'

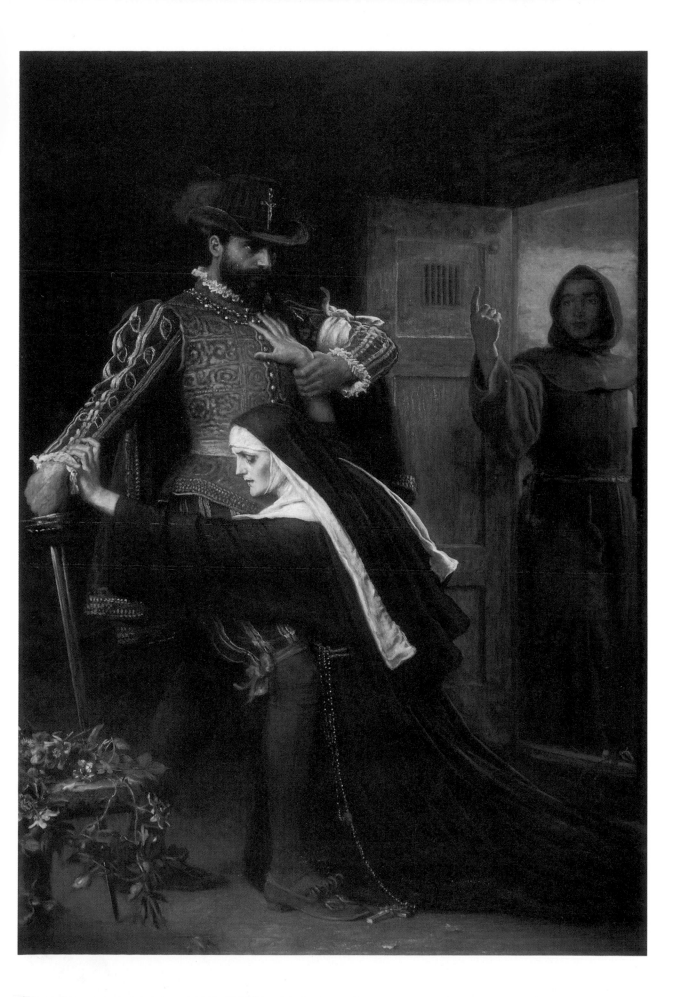

SELECT BIBLIOGRAPHY

A. L. Baldry, *Sir John Everett Millais, His Arts and Influence*
London: George Bell & Sons, 1899

Mary Bennett, *Millais PRB–PRA* (exhibition catalogue)
Liverpool & London: Walker Art Gallery and Royal Academy, 1967

Gay Daly, *Pre-Raphaelites in Love*
New York: Ticknor & Fields, 1989

The Drawings of John Everett Millais (exhibition catalogue)
London: Arts Council of Great Britain, 1979

William Gaunt, *The Pre-Raphaelite Tragedy*
London: Jonathan Cape, 1942

Sir William James, *The Order of Release*
London: John Murray, 1948

Mary Lutyens, *Millais and the Ruskins*
London: John Murray, 1967

Geoffroy Millais, *Sir John Everett Millais*
London: Academy Editions, 1979

John Guille Millais, *The Life and Letters of Sir John Everett Millais*
London: Methuen & Co, 1899

The Pre-Raphaelites (exhibition catalogue)
London: The Tate Gallery and Penguin Books, 1984

John Ruskin, *Notes on Some of the Principal Pictures of
Sir John Everett Millais Exhibited at the Grosvenor Gallery, 1886*
London: Grosvenor Gallery, 1886

Marion H. Spielmann, *Millais and His Works*
Edinburgh: William Blackwood 1898

Malcolm Warner, *Sir John Everett Millais* (exhibition catalogue)
Jersey: La Société Jersaise and The States of Jersey, 1979

J. N. P. Watson, *Millais: Three Generations in Nature, Art & Sport*
London: The Sportsman's Press, 1988